NEWBORN PUPPIES

Library of Congress Cataloging-in-Publication Data available.

ISBN 978-1-4521-1431-6

Manufactured in China

Designed by Marina Sauri

10 9 8 7 6 5 4 3 2 1

Chronicle Books LLC
680 Second Street
San Francisco, California 94107
www.chroniclebooks.com

NEWBORN PUPPIES

DOGS IN THEIR FIRST THREE WEEKS

Traer Scott

CHRONICLE BOOKS

SAN FRANCISCO

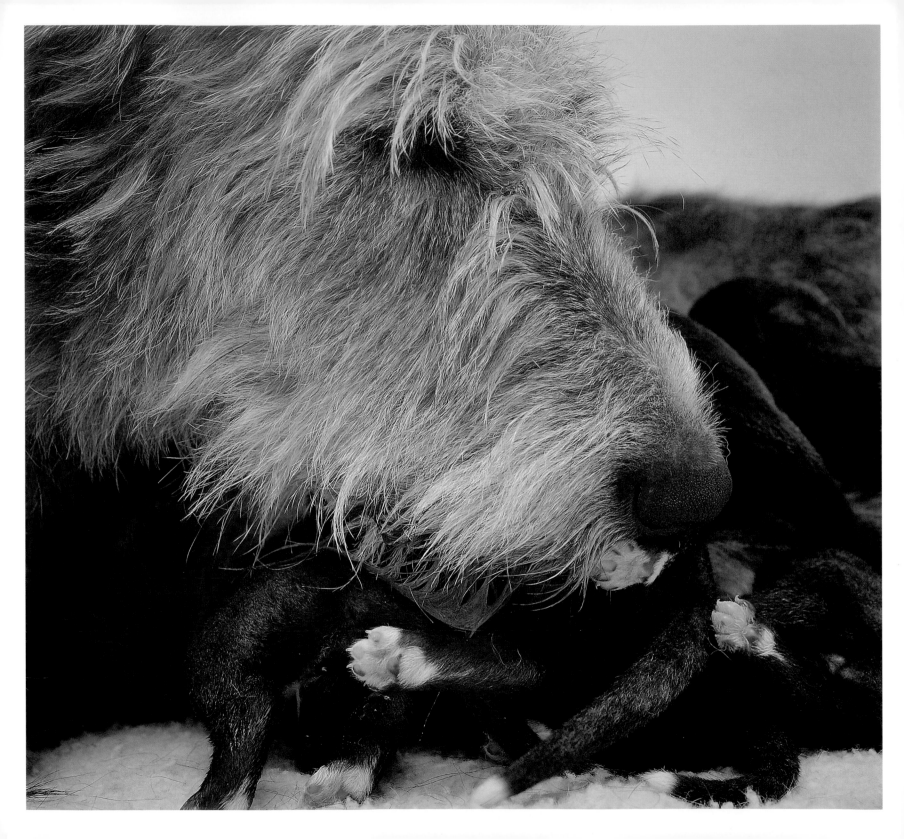

For Agatha, my very own tiny miracle.

Introduction:
The Newborn Puppy

Traer Scott

I don't apologize for loving puppies. They are blissful little creatures whose downy fur, sweet breath, and soft sounds are irresistible. I want to nuzzle them, breathe them in, and find a way to fill myself with their little puppy essence. Somehow, though, puppy love has developed a bad rap. Perhaps too many cards and calendars featuring wiggly little furballs spilling out of baskets or gamboling after playful kittens have left us with the feeling that celebrating the wonder of puppies is best left to eight-year-old girls. I am here to challenge that notion with dozens of photos of the youngest dogs you have probably never seen.

In this book, you will find a great variety of breeds and mixes, all between the ages of one and twenty-one days old. Between breeds, dogs exhibit extensive physical variations. They are, in fact, the most physically diverse land mammal species on earth. Despite the enormous distinctions in appearance, size, and personality that reveal themselves later on, seeing puppies at this age, it's no surprise that all dog breeds actually share 99.8 percent of the same DNA. In taking these photos, I often marveled at the overwhelming similarities that dogs share at this stage in life.

I chose twenty-one days as the cutoff for my subjects because I feel that it represents a crucial developmental turning point. After three weeks, puppies start to look and act more clearly like the dogs they will grow up to be. They also become very familiar to us, what we envision when someone says "puppy." But these early days also show a stage of canine life that few get to witness, and represent a time of remarkable growth, fragility, and change. Like some other mammals, dogs are born completely blind and deaf, with only a strong sense of smell to guide them to mother's milk. Within twenty-one days, puppies go from being barely distinguishable as canines to walking, growling, playing, and even barking. Scientifically speaking, two crucial developmental periods are found within this time: the Neonatal Period, which spans from birth to thirteen days, and the Transitional Period falling between thirteen and twenty-one days.

When human babies are born, they are completely dependent on their parents for every single aspect of survival. For this reason, many pediatricians now refer to the first three months of human life as the "fourth trimester," a delicate period of time following birth when a newborn baby slowly acclimates to life outside the womb as their brain and central nervous system mature. Likewise, during the Neonatal Period, puppies are little more than "fetuses out of the womb." They cannot hear or see and their responses are

purely reflexive. Puppies cannot control their own body temperature and therefore must rely on proximity to their mother or littermates to stay warm. Movement during the first thirteen days is limited to paddling or "crawling" back and forth and sometimes swinging their heads from side to side, which helps to further develop their muscles and nervous systems. A puppy's weight will double in the first week of life.

The Transitional Period, spanning only one week, is characterized by rapid progress in a puppy's physical and mental development. Their eyes and ears, formerly sealed, finally open, revealing the world outside the womb. Puppies see their mother and siblings for the first time as well as getting a first look at their human caretakers. During days fourteen through twenty-one, puppies typically develop their first teeth, begin wagging their tales, barking, growling, and even start initiating play with littermates. By the end of the Transitional Period, puppies have normally taken their first steps and are often able to venture out of the whelping box.

Although these developmental periods are applicable to all dog breeds, the specific rate at which puppies mature varies from breed to breed and litter to litter. For example, the Italian Spinone litter that I photographed at twenty-one days old

had just taken their first steps the day before my arrival. The puppies were large, awkward, and still very inept at movement or balance. In contrast, the Beagle/Pointer litter, twenty days old and quite a bit smaller, was extremely mobile and dexterous, having been walking for almost a week. Variations like this are one of the things that make this book not only fun but fascinating.

In making *The Newborn Puppy*, I worked only with shelters, families with "oops" litters, and hobby breeders who raise their puppies by hand in their homes. As I worked, the photos revealed themselves through the puppies' behavior, body language, and response to outside stimuli. I never planned a pose or approach. It all happened organically, and I loved every minute of it. Some of my subjects are the offspring of champions while others are from the unwanted litters of strays. Whether show dog or mutt, pedigree or puzzling heritage, every one of these little puppies is equally exquisite and about to embark on the very great adventure of growing up.

It is no secret that I am smitten with dogs.
I love to marvel at the difference between a Sighthound and a Shitzu, to witness the intense herding instinct of a Border Collie, the keen tracking ability of a Bloodhound, the lithe silhouette of an Afghan, or the webbed feet of the

water-loving Lab. Of course these are not just charming traits, but useful and cultivated characteristics. Sometimes it's easy to forget that dogs have been bred for millennia for a multitude of highly practical uses, usually the least of which is to curl up at our feet. The form and function of our dogs have been honed over centuries through selective breeding with a number of specific purposes in mind: herding, retrieving, guarding, hunting, and in the case of some toy breeds, pure companionship. Although most dogs in the western world no longer hold "jobs," these physical adaptations and personality traits remain strong and distinguishable amongst purebreds.

Those deeply involved in rescue, who see the brutal realities of pet overpopulation on a day-to-day basis, often call for all breeding to cease until there are no more homeless animals. I used to feel the same way, but an end to breeding would actually mean the end of every breed variation we have and hold dear. If breeders stopped producing litters, all of these spectacular bloodlines and beautiful differences between dogs would not-so-slowly melt back into one big homogenous gene pool. Personally, I think this would be a devastating loss. If responsible breeders alone produced litters, we wouldn't have an overpopulation epidemic in this country. They are not the problem.

It is estimated that up to one-third of dogs in shelters are purebreds, but the overwhelming majority are mutts. Although I am accepting of responsible breeding, I will always choose adoption and encourage others to do the same. Despite my passionate (yet impractical) desire for an Irish Wolfhound, and the fact that every breed in existence has about a million dedicated breed rescues now, I will probably always have mutts. Why? Because mutts are often more in need of homes, but they're also smart and strong and spirited. Another reason to love mutts: you generally get the best of several worlds, so to speak. My Pit mix, Audrey, raised from a five-week-old puppy, has the traits of many breeds in her muddled bloodline and is a water-loving, Frisbee-catching nanny dog with fierce intelligence.

Of course, like most mutts, Audrey is only here because someone screwed up. Audrey's mother, a brindle "Pocket Pit" eventually named Lily, was not spayed, got loose, got pregnant, and ended up in a local shelter inches from death. At some point Lily was a puppy who someone thought was precious — until she grew up. This is the fate of many puppies whose only crime is maturing. Unlike Lily, millions of adult dogs are not rescued in time.

Although there are exceptions, most shelters have no trouble placing puppies. At our shelter, we have anywhere between five and twenty applicants *per puppy*. With the majority of the applicants destined for disappointment, we obviously always try to interest them in one of the young but fully grown dogs that we have for adoption—many of which have been waiting months for a new home. In the end, very few people who apply for a puppy actually opt to adopt a young adult dog, even when they are only ten or eleven months old and still considered a "puppy" by age if not appearance. There are a number of reasons for this, including myths about trainability and temperament, but one reason is biological.

As both humans and mammals, we are hard-wired with the urge to nurture—and this often extends to nurturing baby animals as well as baby humans. Like so many mammals, this biological need to nurture is the only reason that our species has survived. I am constantly reminded of this when my infant daughter wakes up screaming at 3 A.M. needing to be fed, then proceeds to vomit her meal back up onto my pajamas. My only response is to cuddle her until she goes back to sleep. Nothing but an irrepressible nurturing instinct can account for such illogical behavior. But when your infant gazes at you, or flashes a toothless smile in your direction, it

somehow all seems worthwhile. When we see puppies, with their big eyes looking up at us, their tiny voices whimpering or crying, we want to nurture them, too, and in fact we often crave the opportunity.

By the time our human children are thirteen or so, slamming doors in our faces and sometimes calling us names not suitable for even HBO, we have grown so attached to them that we tolerate the temporary abuse because we're deeply invested. Likewise, once our puppies are no longer tiny and helpless but chewing up everything in sight, barking relentlessly, and planting muddy paws on the couch, we are too attached to sever the relationship. Most of us also know that eventually an adolescent dog, just like an adolescent child, will bloom into a gratifying adult companion. Unfortunately, though, many people have a kind of disconnect that allows them to view dogs as disposable and replaceable. These are the people responsible for populating our shelters with an estimated four million dogs annually: dogs whose owners had no more use for them, couldn't be bothered to claim them when they got lost, or surrendered them because their lives could no longer accommodate a dog. In many cases, these dogs were given up simply because they were no longer puppies. Although I will not pretend that is the same, in my opinion, this

desertion is akin to abandoning a child. Even though they are not born of us, our dogs are members of the family. A dog is for life.

When I began shooting this book, I was pregnant with my daughter. Perhaps it was the rush of maternal hormones that first sparked the idea for this project. I remember that the concept came to me in the middle of the night. I sat on the floor by my bed writing furiously in a notebook by flashlight to avoid waking my husband, and a few weeks later I began searching for puppies. As this project progressed, so did my pregnancy. My little baby grew bigger and bigger until her hands and feet became visible on the outside of my belly as she stretched and pushed from inside. After she was born and I began working again, I couldn't help but notice similarities between myself and the new mothers I was photographing.

I was able to access one litter, born to a tiny Terrier mix at our municipal animal shelter, when they were only twenty-four hours old. I was doing my regular volunteer shift when staff informed me that a dog had delivered the day before. I ran home and got my camera. Mama and her three pups had been moved to a quiet, secluded room and given a crate as a "den." The tiny puppies were cozied up in blankets inside the crate, so

small they looked more like mice than dogs. Our shelter director, Dave, carefully took each puppy out and placed it on a clean blanket that we had brought in for the photos. Mama watched closely as we did this and as soon as each puppy made it out of the crate and was placed on the blanket, she gingerly picked it up in her mouth and carried it, squealing, back into the den. She did this over and over again. She showed no animosity toward us and no anxiety about the situation, just a determined sense of duty.

After it became clear that I would not get any shots of this litter without removing Mama from the equation, Dave picked her up and held her in his arms while I once again moved the pups to the blanket outside the crate. Suddenly restrained and unable to reach her puppies, Mama began thrashing about and crying, struggling with all her strength to get free and return to her babies. The separation was clearly torturous to her. We quickly reunited her with her litter and her heart rate immediately returned to normal, she stopped crying and was visibly calm again, but she remained wary of us for the rest of the day. As a new mother, I could completely empathize with this little dog's anguish.

At this point, my daughter Agatha, only five months old, had just begun to spend occasional days with

her grandparents as we tried to work full-time jobs back into our schedules. At the end of the day, when I knew my husband was on his way home with her, I would literally sit on the edge of the couch with my eyes fixed on the door, foot tapping, overcome with a fierce, physical yearning to see my baby. It is not simply a desire or wish but a *need*, like the one I used to feel years ago as a smoker after having gone too long without a cigarette. When I heard the car drive up I started pacing, and when the door was flung open I raced to scoop up Agatha. With my daughter in my arms, I suddenly felt happy and calm. Although our attachment to our children is undoubtedly more complicated due to our capacity for complex emotion and thought, the imperative behind the attachment is clearly innate and very much the same as what a dog feels. Imagine, then, a dog that is constantly forced to breed only to have every litter snatched away from her at a few weeks of age.

Hopefully, many readers will have heard of puppy mills. Having received a lot of attention in the mainstream media in the past five years, "puppy mill" is now a familiar term. They are known to many as horrendous puppy "factories" distinguished by their inhumane conditions and constant breeding of unhealthy and genetically defective dogs solely for profit. These are appalling

places where dozens of purebred female dogs are kept in extremely brutal conditions and forced to produce litter after litter until they are no longer able, at which time they are disposed of. Often these dogs, many less than five years old, are beaten to death, euthanized, or sold to laboratories for research; only a small handful are re-homed. To many people, though, puppy mills are still an abstract concept that happens "somewhere else." I have heard well-meaning dog owners emphatically say "I would never buy a dog from a puppy mill!" but whose dogs came from their local pet stores.

In fact, most puppy mill dogs end up at your "local pet store." The approximately 3,500 pet stores in the United States sell roughly 500,000 puppy mill puppies a year. These pet stores traditionally offer only vague, shadowy details about the puppies' origins. A customer might be told that the puppy came from "a farm in upstate New York" or a "nice breeder in the Midwest." According to the ASPCA, the records of origin and lineage for puppy mill dogs are also often falsified.

So how does a puppy from Oklahoma or Kansas end up in a pet shop in Manhattan? Puppies from mills are generally taken from their mothers at five to eight weeks of age and then sold

to a broker or middleman who ships them to pet stores by truck or plane and often without adequate food, water, ventilation, or shelter. The puppies are frequently unhealthy and often possess genetic or psychological problems. Common ailments found in puppy mill dogs include heart disease, epilepsy, kidney disease, and deafness. Many die at a young age.

Puppy mills are a multimillion-dollar industry and the sole reason that they thrive is that people continue to buy the product. That's exactly what puppy mill dogs are: product. When we refuse to purchase a dog from a pet store and insist instead on adoption or on buying only from reputable breeders, then we will put puppy mills out of business for good.

Prospective dog owners should also watch out for online broker sites, which can be even more deceptive than pet stores, showing colorful photos of happy puppies for sale and their healthy parent dogs, with rolling green hills and quaint little farmhouses in the background. Likely, these are stock photos purchased from agencies and the puppy you get will probably not be the one in the photo. If a broker offers to ship a puppy sight unseen, beware.

Besides, whenever possible, it's always a good idea to meet a dog face to face before you bring him or her home. I can't even count how many people have come in to the shelter where I volunteer, dead set on adopting a specific dog—positively swooning over him, having fallen in love with his picture online. Nine times out of ten, when we introduce them to this same dog outside of his kennel, they are very disappointed to find that that he just isn't the right dog for them. Maybe they have small children and this dog is too jumpy, or they are put off by his energy level. Perhaps the family wants a snuggly, needy companion but the dog completely ignores them, preferring instead to march around and pee on everything in sight. Usually at this point, we suggest other dogs who we feel may fit their lifestyle better and, quite often, a happy ending is coaxed from initial disappointment. I liken this to online dating. Sure, you can fall in love with a flattering photo and a few lines of text, calling it "love at first sight" but what you're really doing is projecting all of your hopes and desires into the plentiful blanks. While dogs are plainly *not* people, adding a puppy to your family does mean welcoming a new sentient being that will bring its own personality and preferences, a being who will share your home and your heart for the next ten to fifteen years.

Although few people get to witness the fascinating period of infancy chronicled in this book, it is, after all, only one piece of "puppyhood." A dog is still considered a puppy until at least one year of age or longer, depending on the breed. During these first months of life, rapid physical and mental development influenced by environmental factors and external stimuli will mold the dog that is to become your friend and constant companion. It is therefore absolutely crucial that a puppy's first months are spent in a safe and nurturing environment with a healthy mother. Responsible breeders know this, and they will take great strides to raise healthy, well-adjusted pups that are poised to live long and happy lives.

Unfortunately, many puppies are brought into the world destined for short lives filled with fear, illness, and anxiety. Puppies that are taken from their mothers too young, housed in cruel or neglectful conditions, not given proper vet care, or left unsocialized, will almost always suffer negative consequences later in life. Puppy mills are the big evil, but indiscriminate, profit-driven backyard breeders are also to blame. The only way to stop this suffering is to *stop buying these puppies* and choose a humane alternative. Choose a responsible breeder; choose adoption; choose to spay or neuter your animal;

choose to speak out when you see inhumane treatment. It really is that simple.

As humans, we alone are responsible for the domestication and proliferation of the dog as a species. Thereby, we are also solely responsible for the millions of homeless dogs in our shelters and on our streets as well as the great deal of suffering that overpopulation causes our dogs. For this reason, I believe very strongly that bringing new (dog) life into the world should be done deliberately and with great care.

I often hear people describe dogs as "little people in fur coats" and I believe that the epithet is meant to show how much we value our dogs and view them as family members. The comparison is clearly meant to be flattering—although to whom I'm not entirely sure. Personally, as someone who has always preferred dogs to people, I'm more inclined to go with author John Holmes, who said, "A dog is not almost human and I know of no greater insult to the canine race than to describe it as such."

Rottweiler/American Staffordshire Terrier Mix

1
day old

Puppies are born with their eyes and ear canals sealed, making them blind and functionally deaf. It is not until around two weeks of age that most dogs begin to gain the ability to see and hear. Until then, they are guided solely by touch and smell.

———————————————

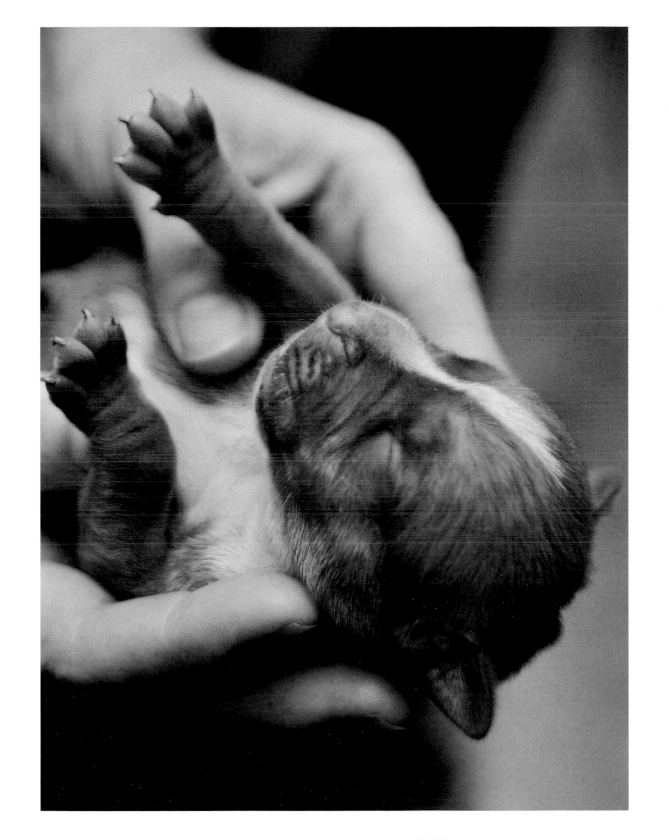

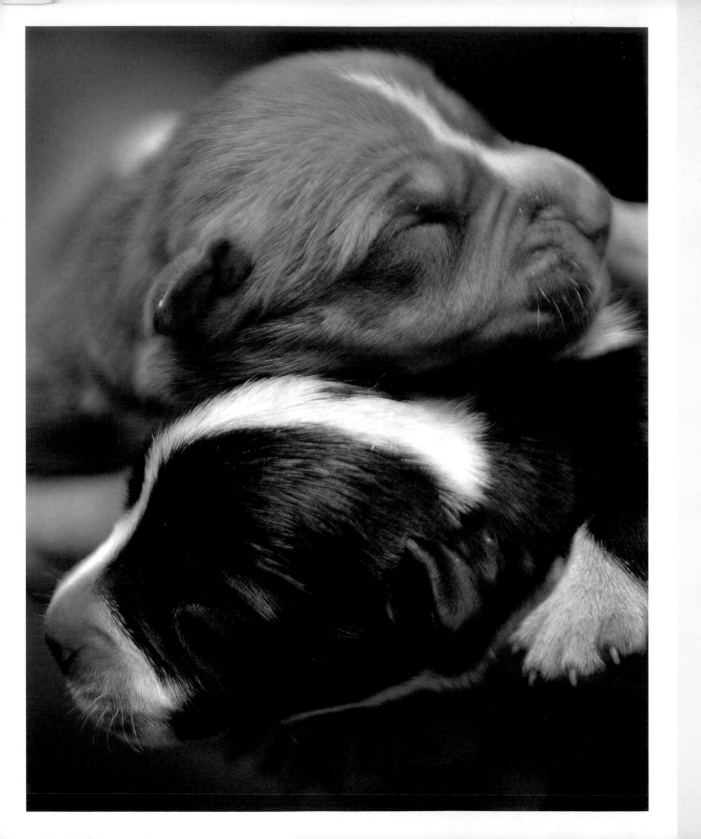

Norwich Terrier Mix

1
day old

This mixed breed litter was born and raised in a municipal city shelter after their emaciated, pregnant mama was picked up as a stray by animal control officers. Isabel, as the tiny, wiry-haired female terrier was named, was a very protective yet gentle mother. As is often the case, the puppies' father remained a mystery, but was generally thought to be a larger dog since by the time the pups were eight weeks old, they were already the same size as Isabel! Mother and all three puppies were adopted into loving homes.

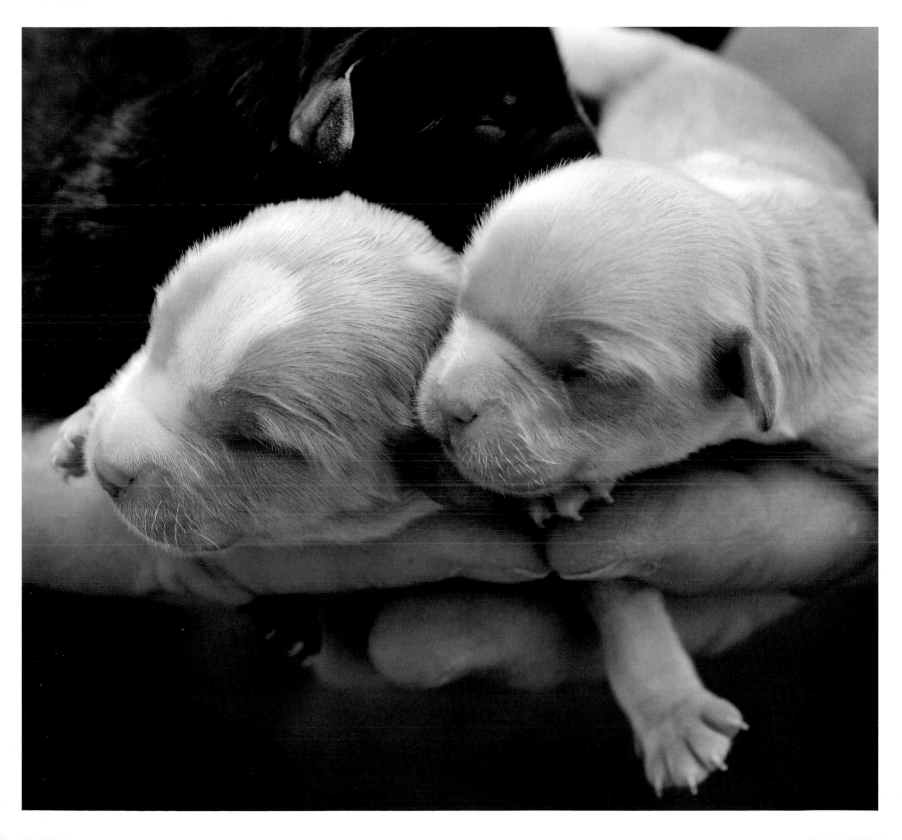

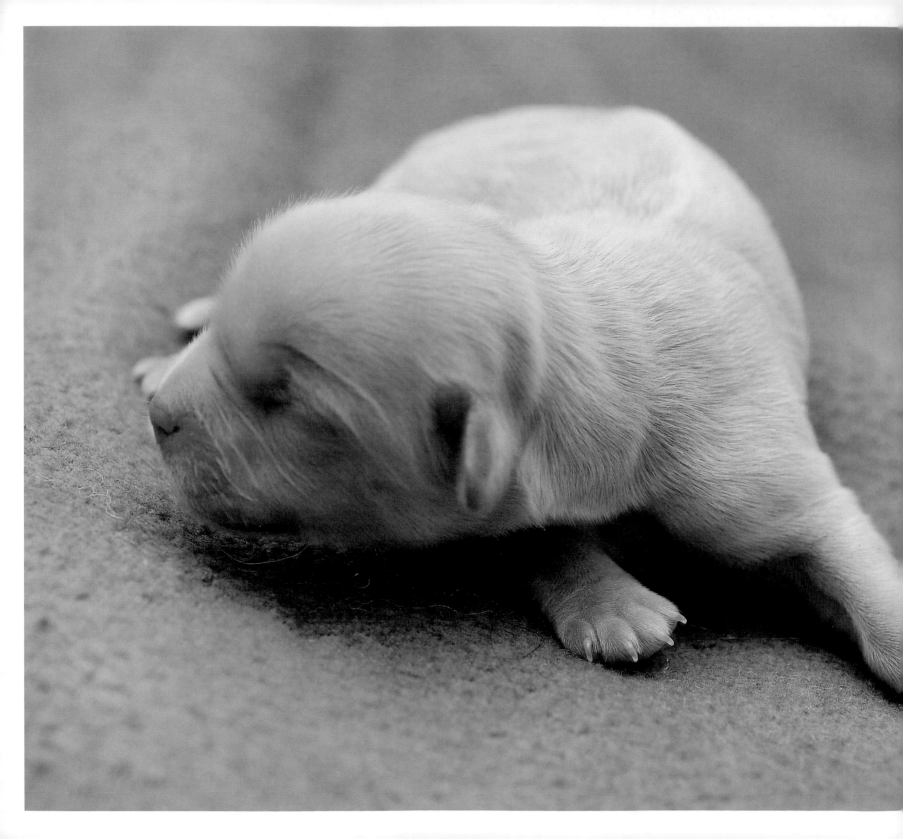

Weimeraners

2 days old

Weimeraners are born with blue
eyes and chipmunk-like stripes,
both of which disappear about one
week after birth.

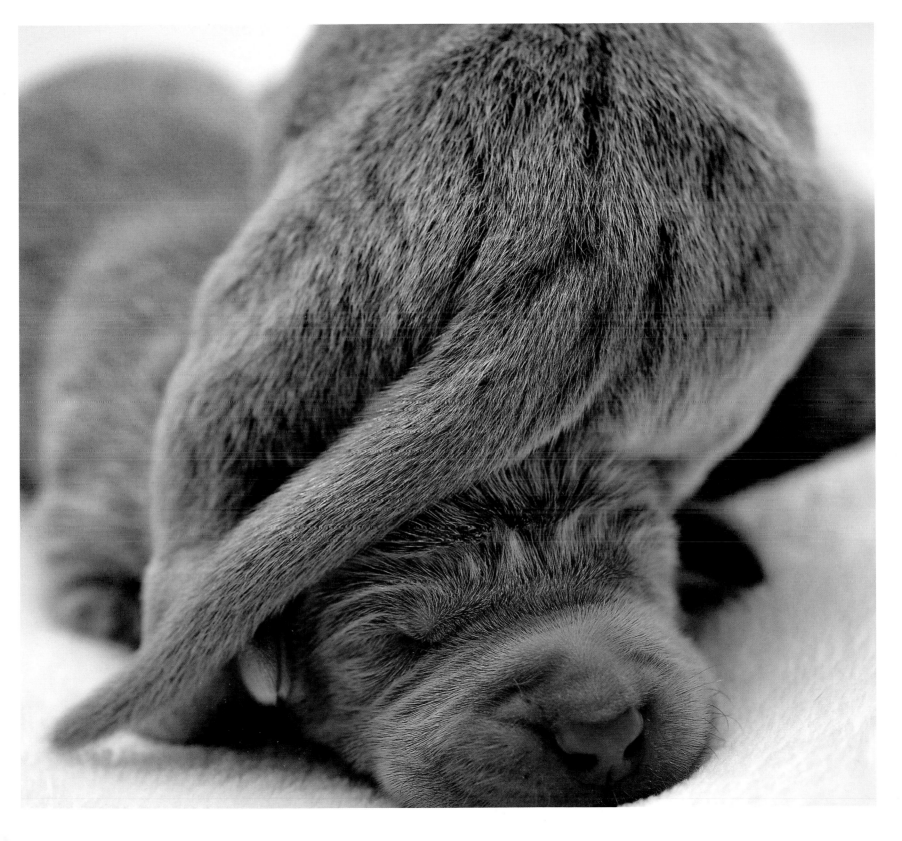

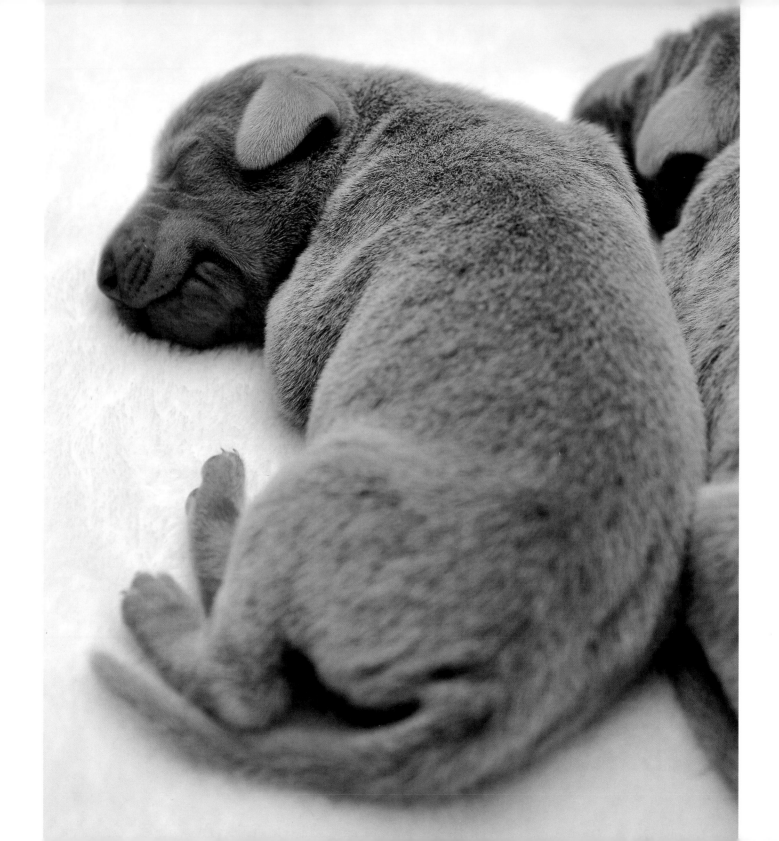

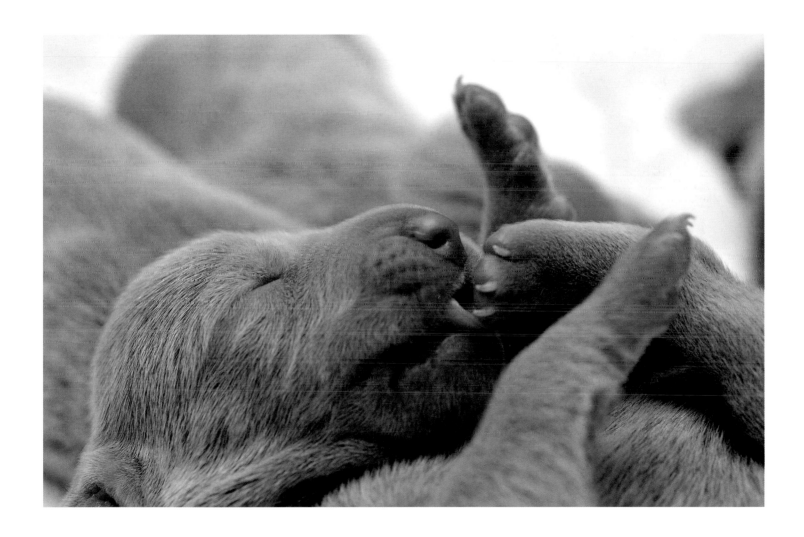

**Soft Coated Wheaten
Terrier/Standard Poodles
Mix (Whoodles)**

2 days old

A family of pasta lovers decided
to name their puppies after the
many varieties of their favorite
food. The two smallest pups were
dubbed Orzo and Ditalini while
the largest, beefiest puppy was
Rigatoni. Ravioli, Penne, Linguini,
and Ziti rounded out the middle.

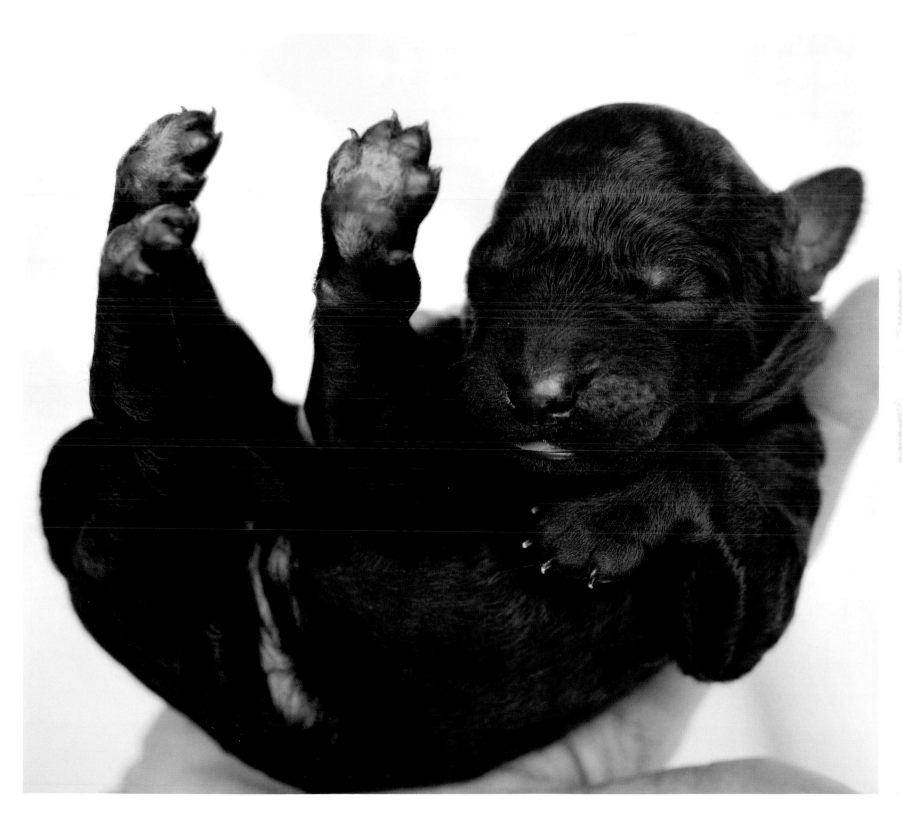

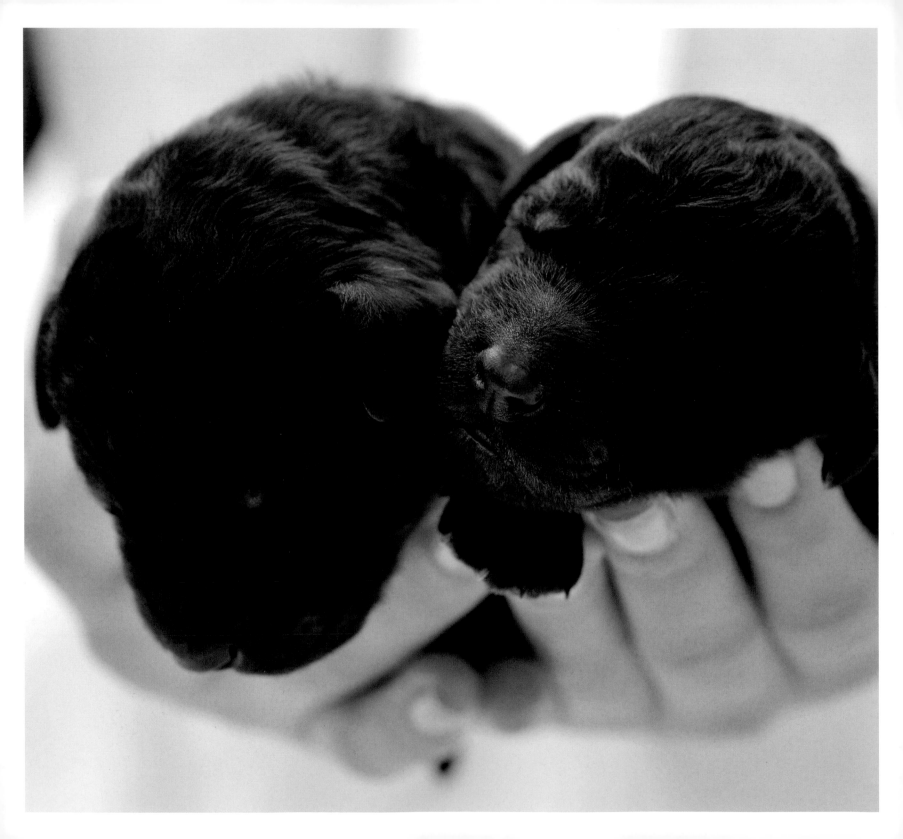

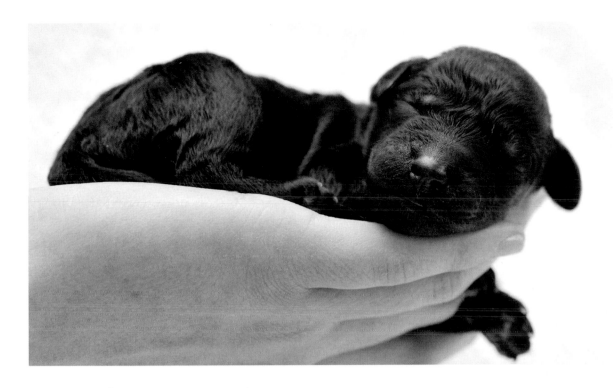

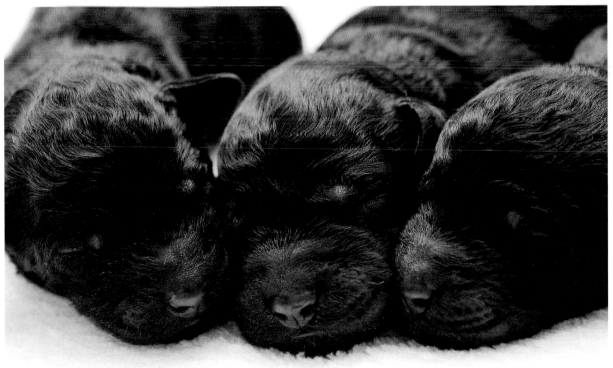

Siberian Huskies

4
days old

Siberian Huskies originated with the indigenous Chukchi people who have inhabited the northern artic coastal region of Siberia for centuries. The semi-nomadic Chukchi were often required to expand their hunting territory and in response, bred dogs with endurance and speed, able to carry light sled loads at moderately fast speeds for long distances through harsh conditions. Sled dog packs made it possible for the Chukchi to hunt remotely and then transport food back to their families. In this way, the Chukchi literally depended on their dogs for survival.

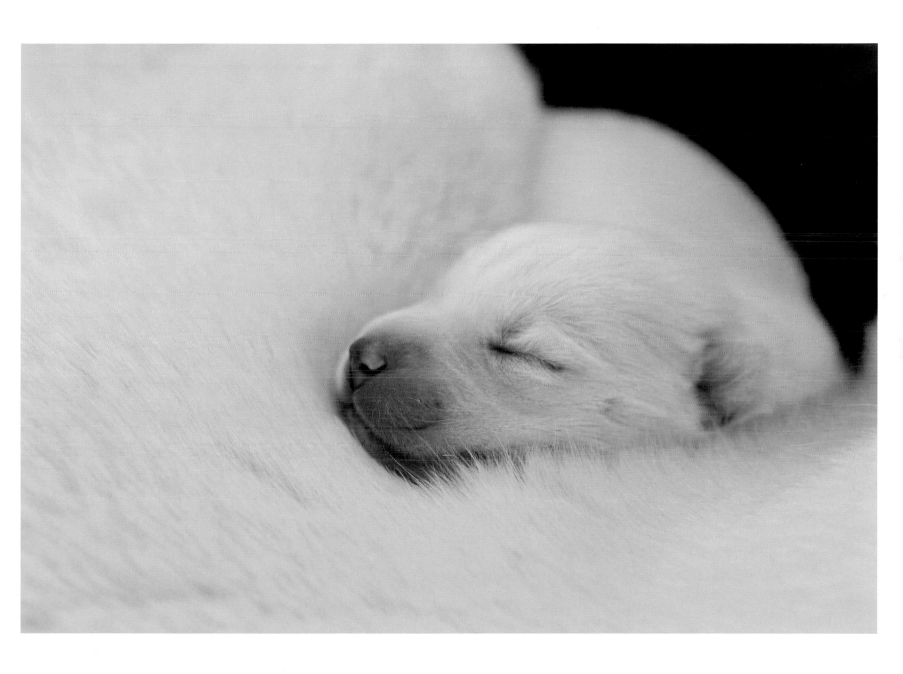

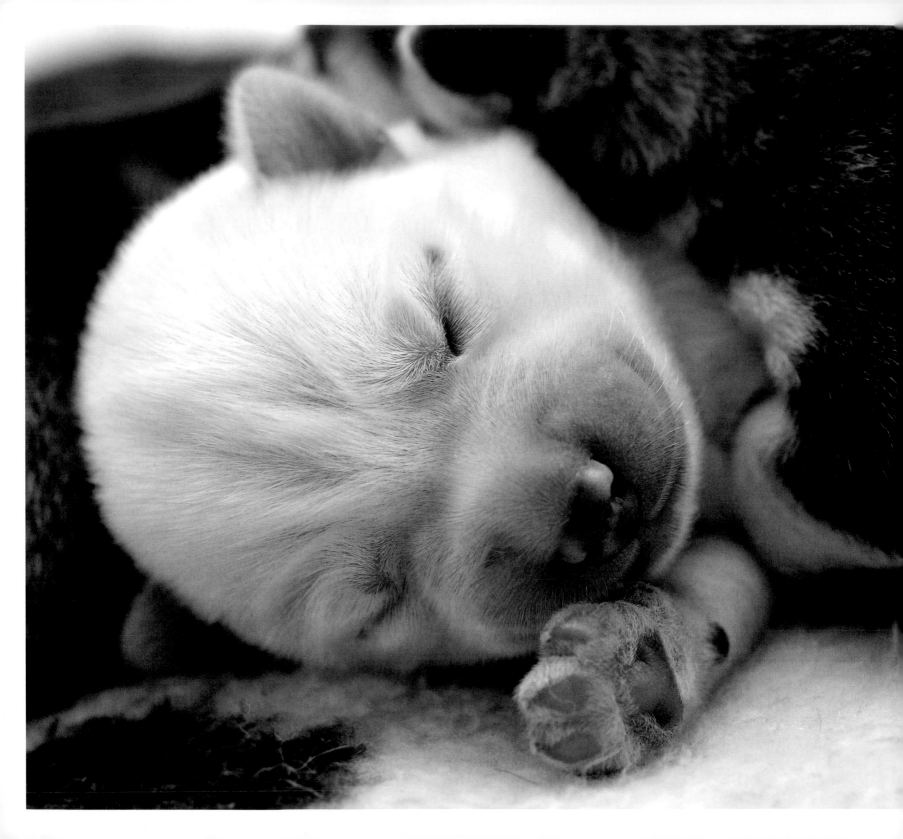

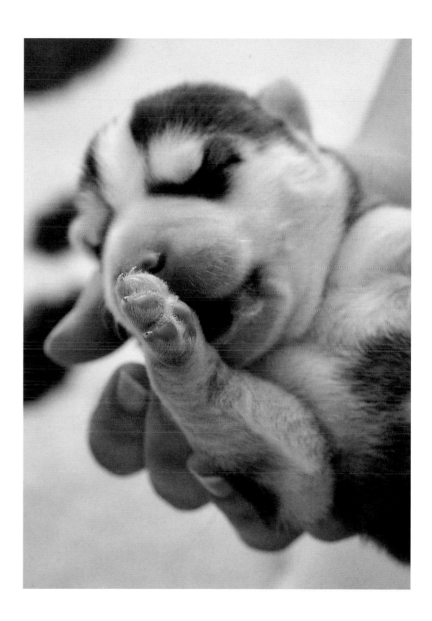

Cockapoos

5
days old

A Cockapoo is a cross between a Cocker Spaniel and a Poodle, but despite being a popular American breed since the mid-1950s, the Cockapoo is not considered a pure-bred because they do not "breed true." This means that Cockapoo puppies do not have reliably pre-dictable characteristics because puppies may inherit the traits of either or both parents, which is why some Cockapoos may look like a Cocker Spaniel while others have the look of a Poodle.

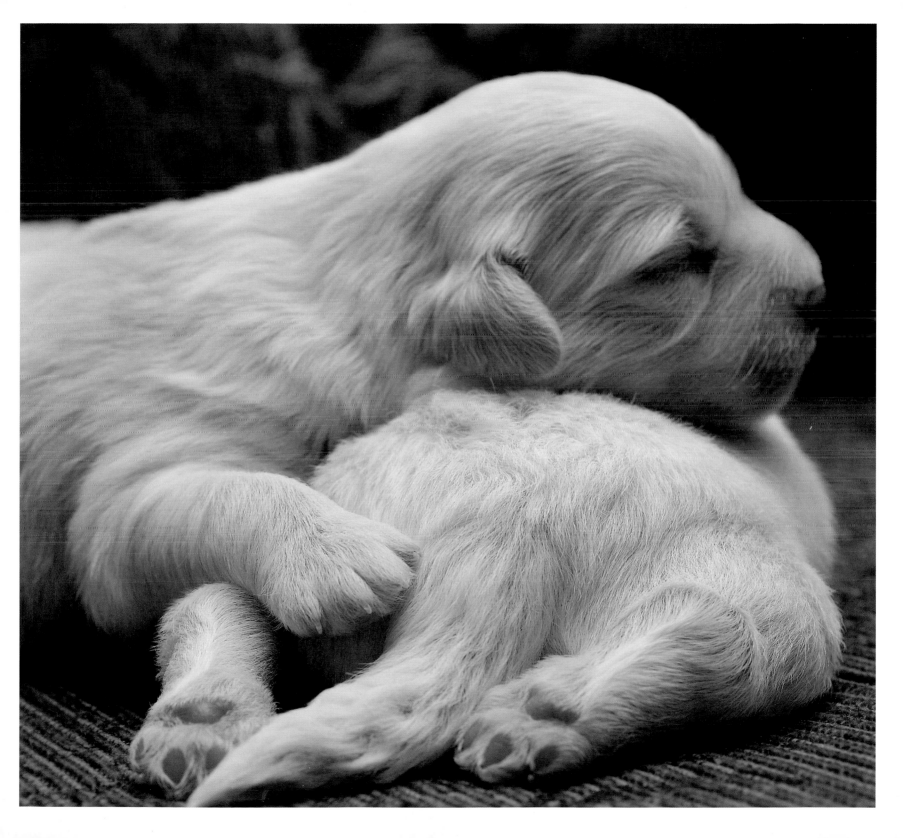

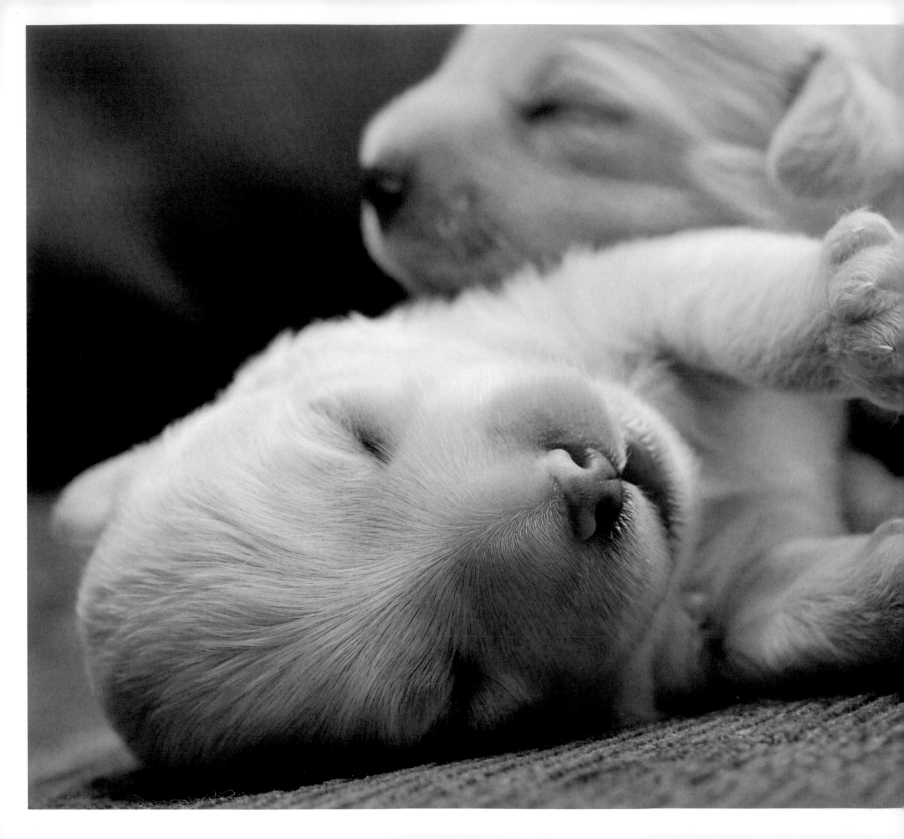

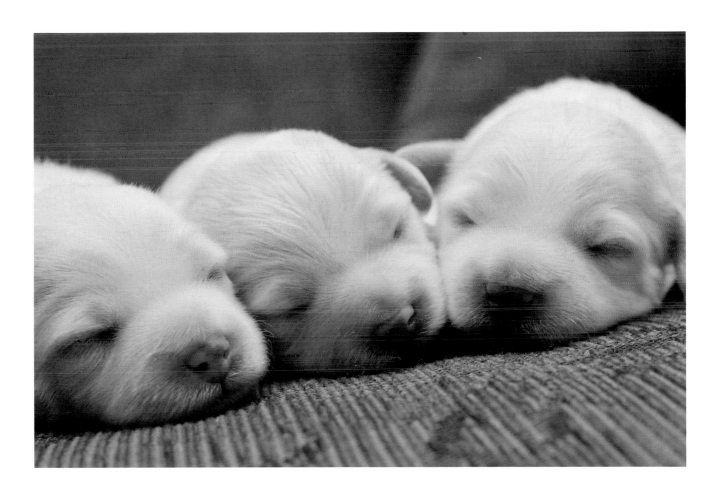

Pomeranian/Chihuahua/
Jack Russell Mix

7 days old

The most important factor determining the number of puppies in a litter is the breed of the parents. Simply put, small dogs tend to have smaller litters than larger dogs. According to an AKC study on litter sizes, a Chihuahua will average two to five puppies per litter with 80 percent of all litters having four puppies or less, while a German Shepherd can expect four to nine puppies. The average litter size for dogs in general is six puppies.

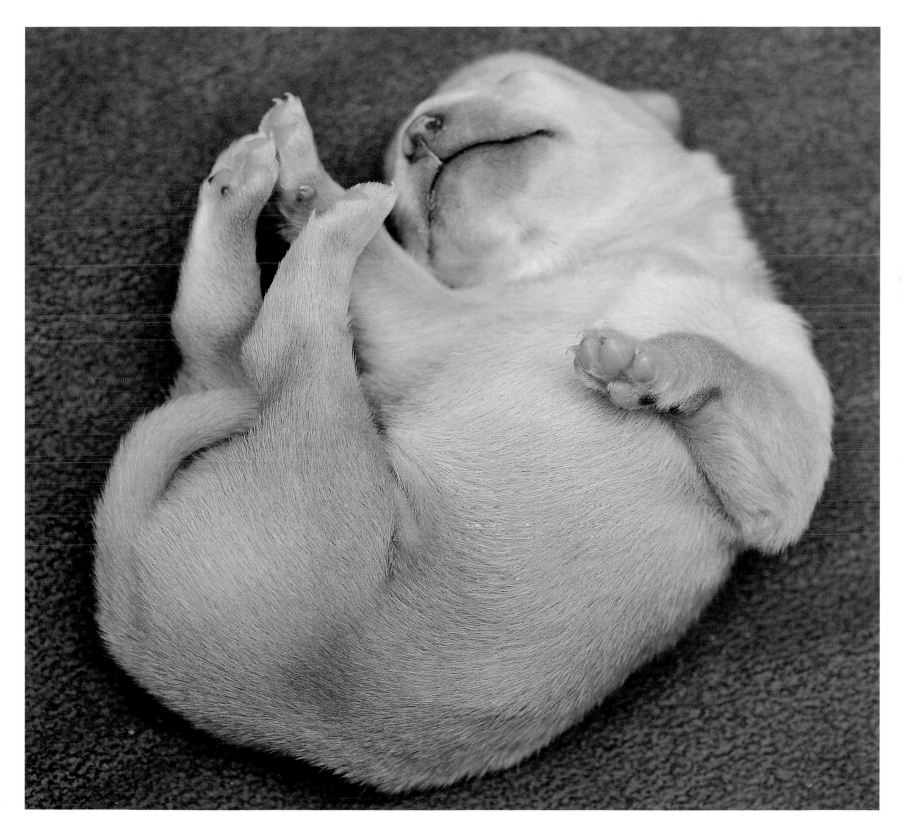

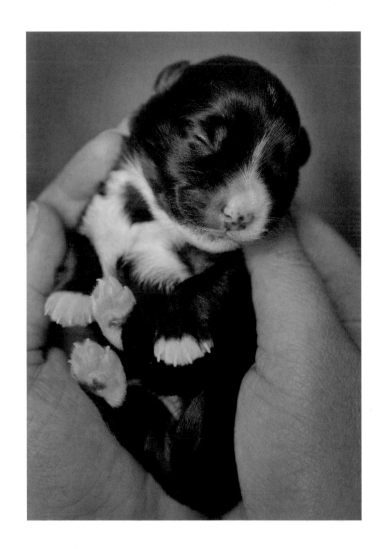

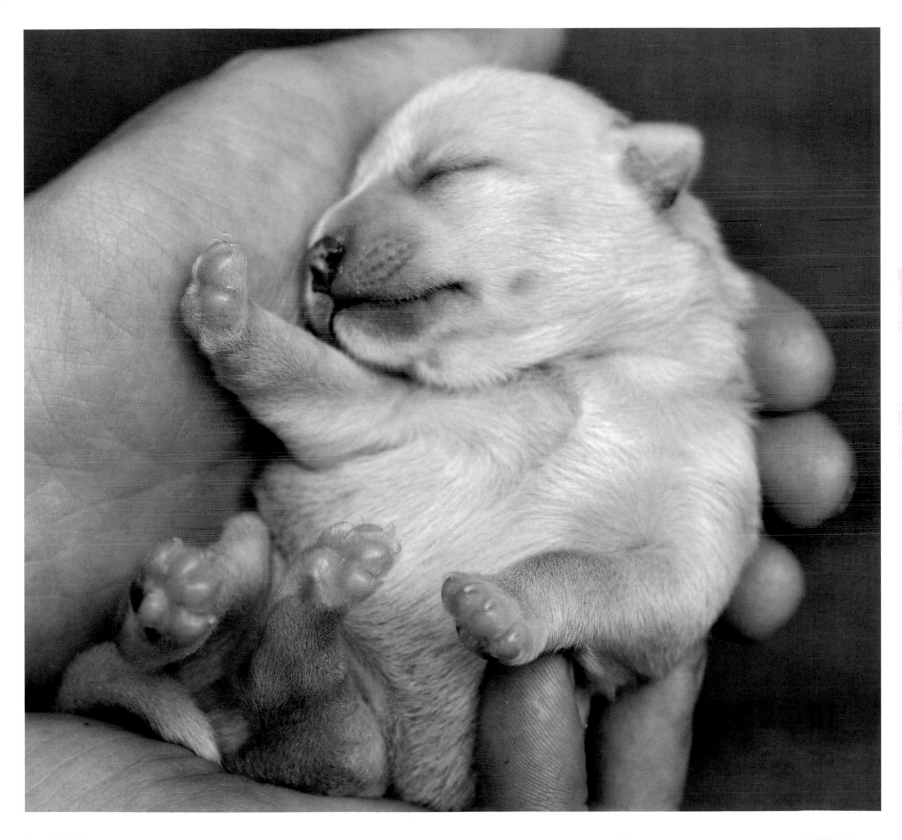

**Irish
Wolfhounds**

9
days old

Irish Wolfhounds are the tallest of
all dog breeds, averaging between
32 and 34 inches at the shoulder.
References to this ancient breed
have been found in wood cuts and
written documents dating back to
273 BC, but by the mid-nineteenth
century, the Wolfhound had almost
entirely vanished. A deliberate
revival by several English breeders
ensured the continuation of the
bloodline and developed the breed
standards which now define the
modern Irish Wolfhound.

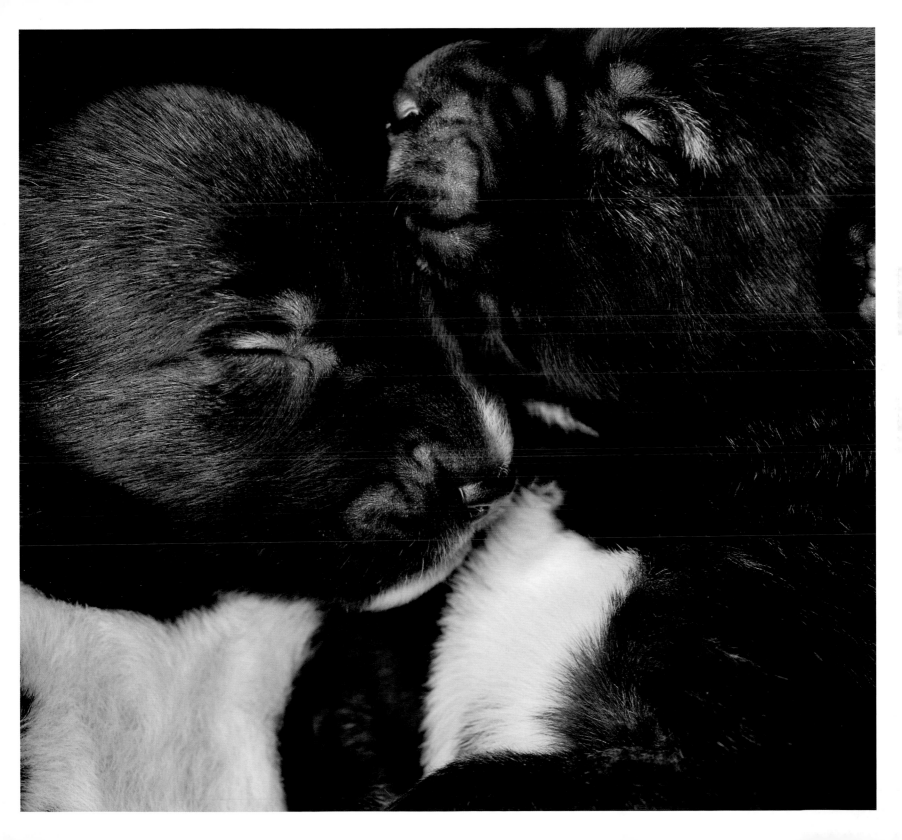

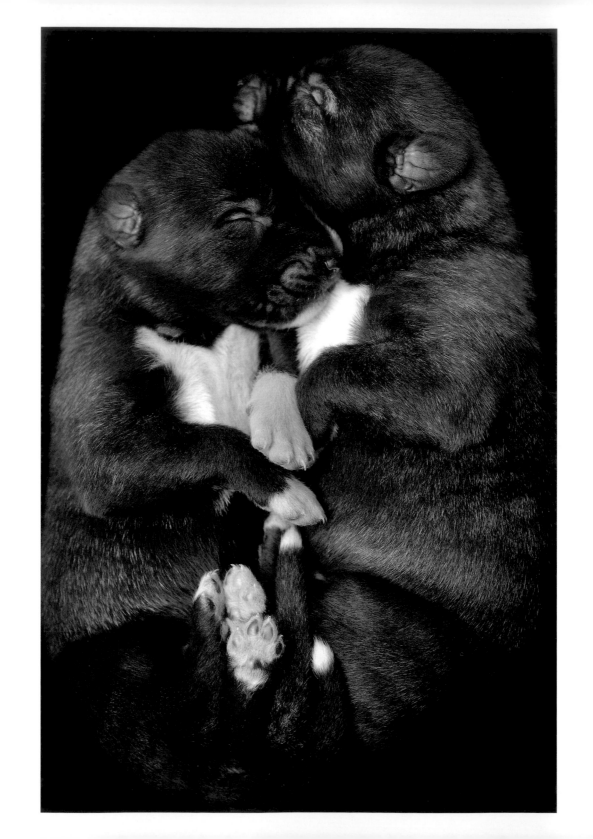

**Cane
Corsos**

9 days old

The Cane Corso is a large Italian
working breed descended from the
now extinct Old Roman Molossian,
legendary war dogs that in addi-
tion to hunting large wild animals,
were considered auxiliary warriors in
battles and often also fought lions,
elephants, and other big game for
sport in ancient Roman arenas.
Eventually these strong, athletic
dogs were transitioned to being
farm workers as well as livestock and
property guardians. Today, modern
Cane Corsos retain their ancestors'
strong protective instincts but are
also known to be gentle and loyal
family dogs.

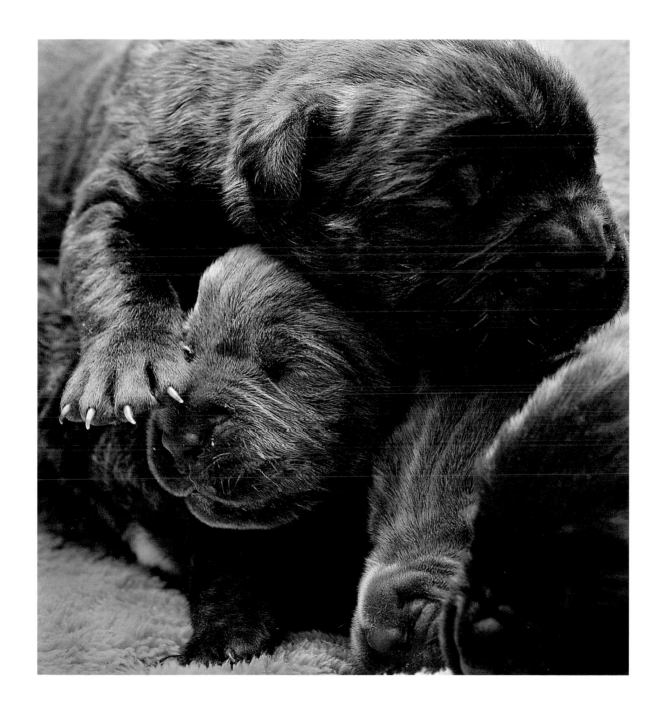

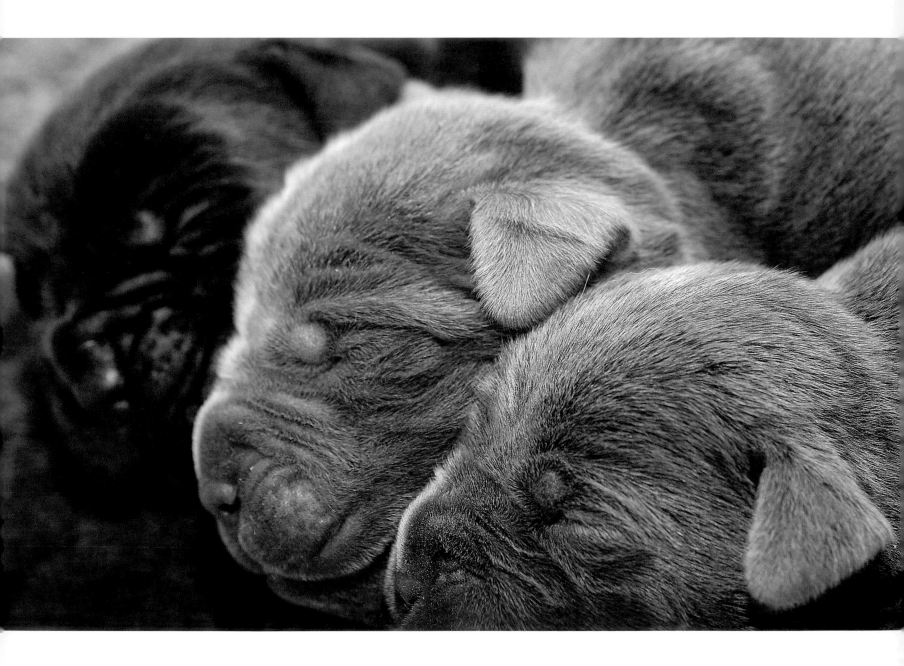

**Shepherd/
Rottweiler Mix**

10
days old

Due to lingering superstitions, mis-
conceptions about aggression, and
other factors, black dogs are fre-
quently overlooked in favor of lighter
colored dogs in shelters. Regard-
less of breed, black dogs will often
be the last to be adopted — if at all.
Fortunately, the puppies in this all
black litter had no problem finding
loving homes.

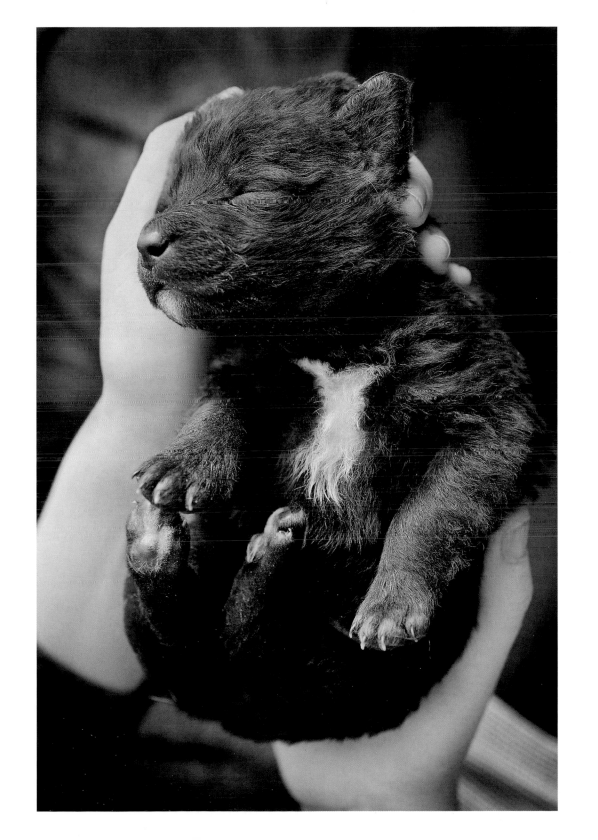

Boston
Terrier/
Bulldog Mix

10
days old

The Boston Terrier has been nick-
named "The American Gentleman"
because of their elegant tuxedo-
like markings, gentle manners, and
suitability as a household compan-
ion. Although black and white is
by far the most common coloring
for a Boston Terrier, they can also
be brindle and white, or seal and
white.

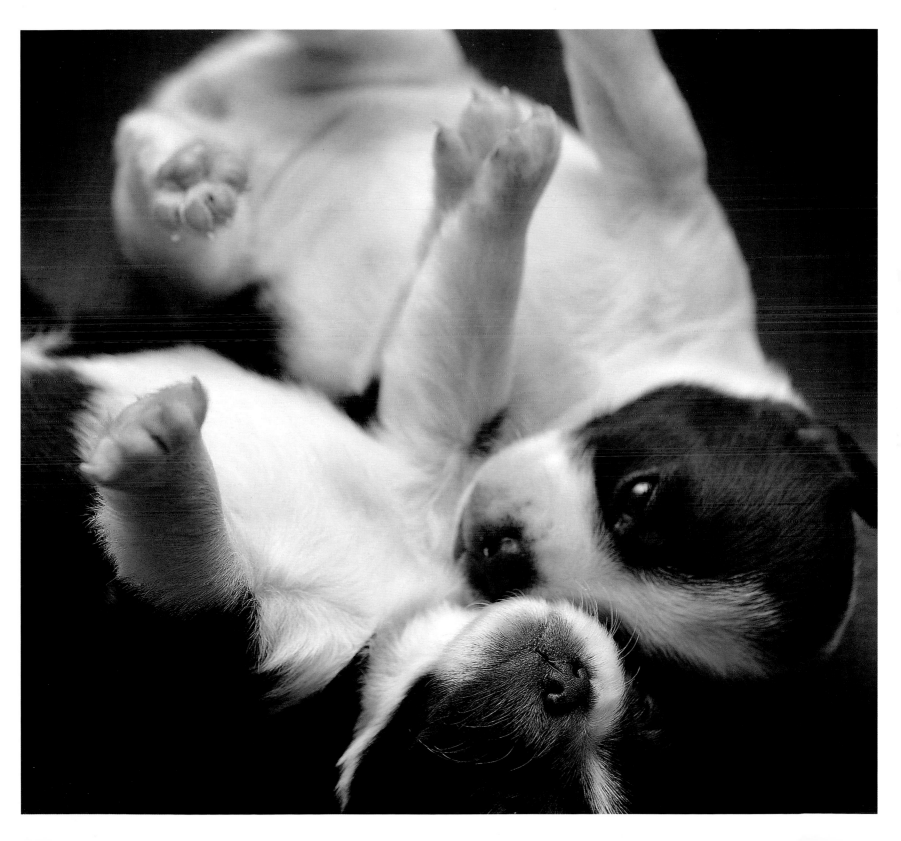

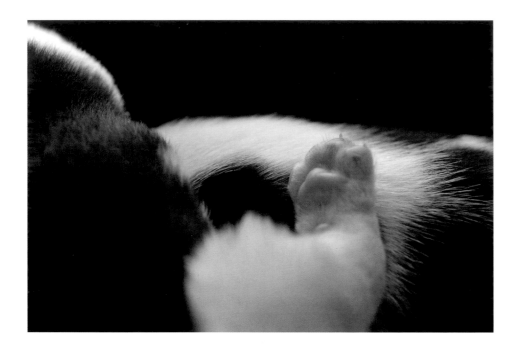

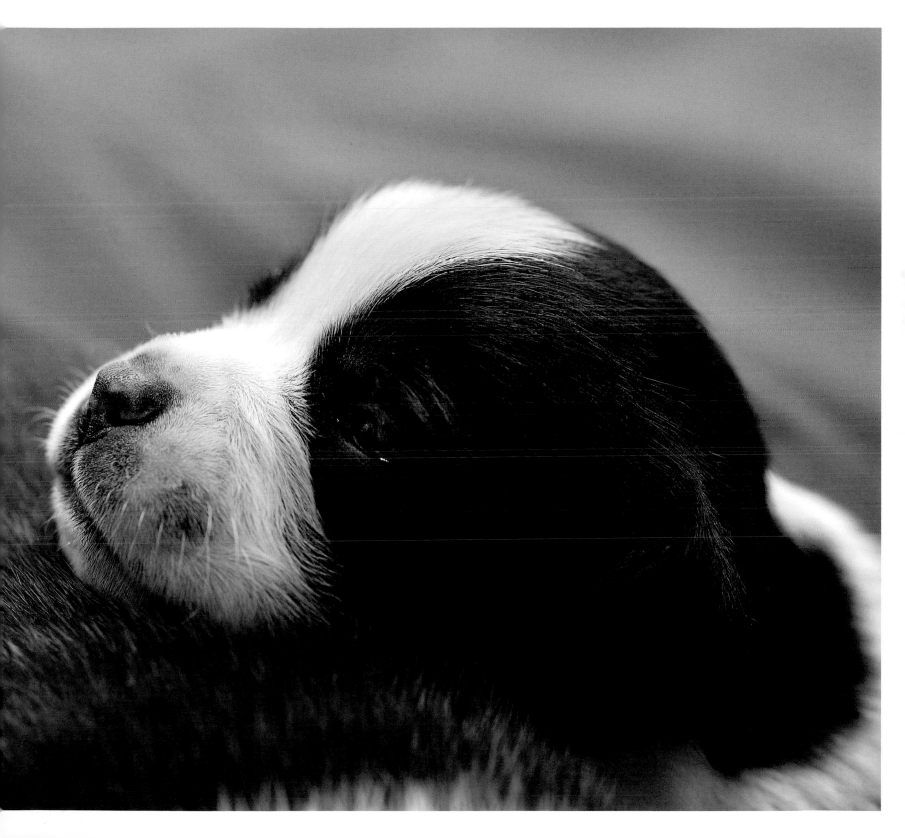

Norfolk Terriers

12
days old

Small but mighty, the Norfolk Terrier originated in England where they were used to rid barns of rats and other vermin. Generally measuring only nine to ten inches at the shoulder, they are the smallest of the working terriers.

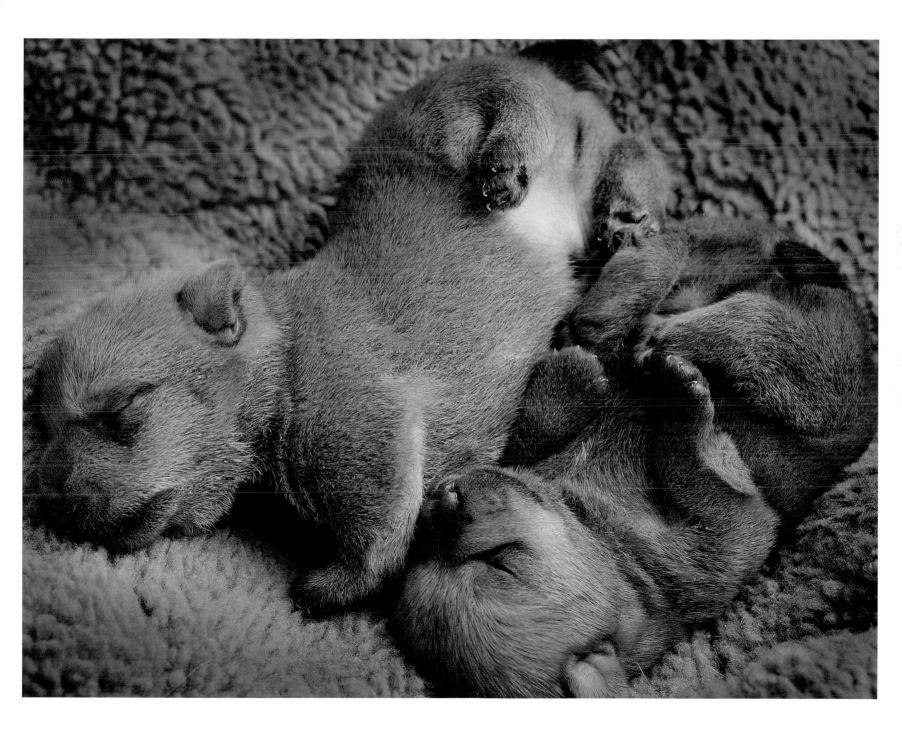

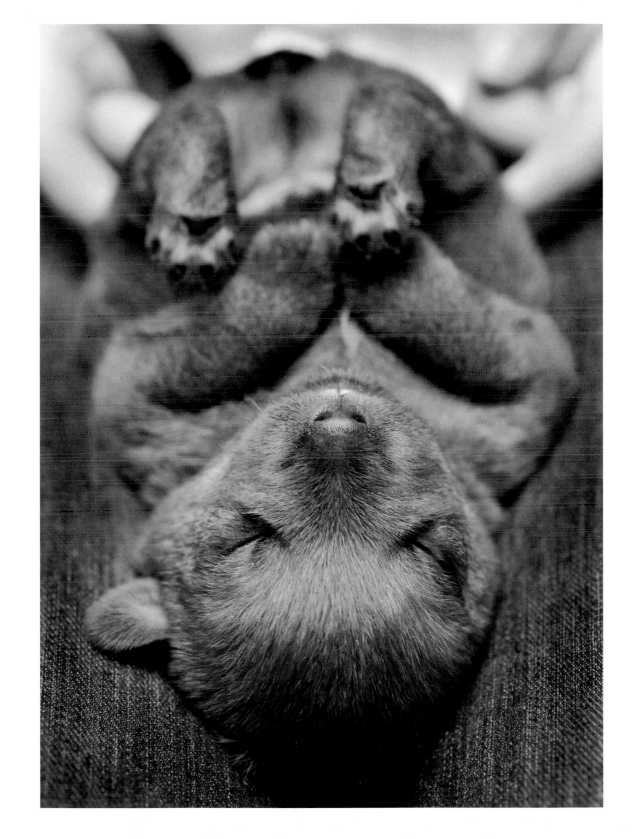

**Bichon Frise/
Chihuahua/
Pekingnese**

12
days old

This litter of mixed breed lap dogs credit their heritage to three of the most popular and ancient small dog breeds in the world. The Chinese Pekingnese is over two thousand years old, the French Bichon Frise dates back to the 1200s, and evidence of a dog very similar to the Chihuahua has been found in Mexican art and writing dating as far back as the ninth century.

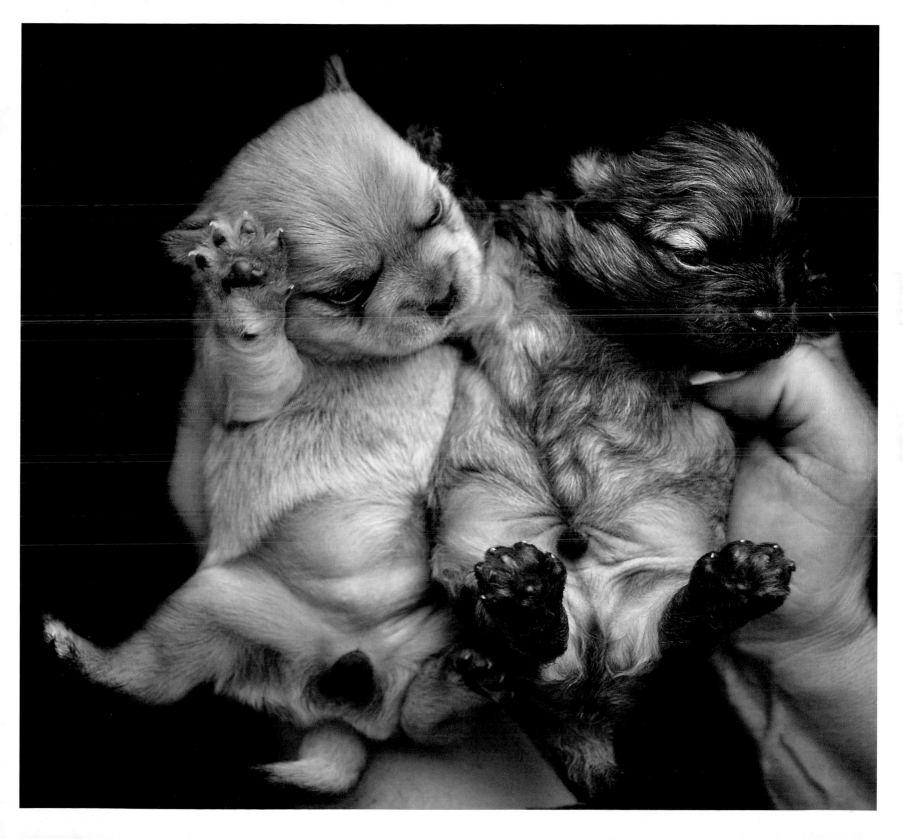

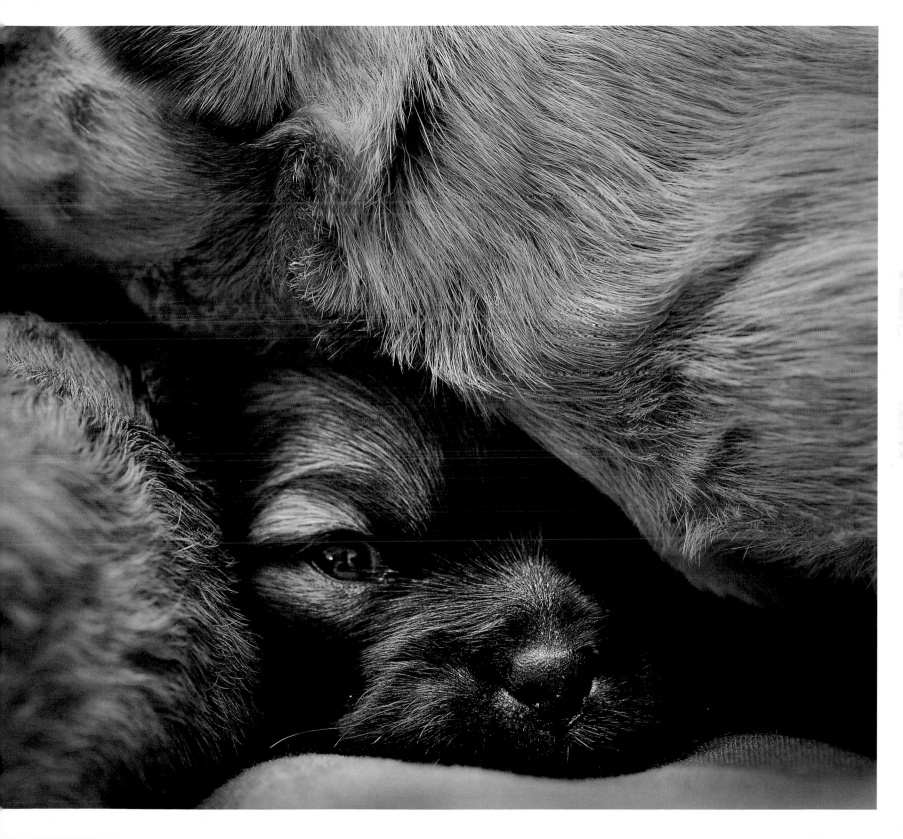

Boxers

13
days old

A relatively new breed, Boxers were first introduced in the late nineteenth century. During World War I, they were used as military messenger dogs, pack carriers and guard dogs. According to 2011 American Kennel Club statistics, Boxers now rank as the seventh most popular breed of dog in the United States. Celebrities who have owned Boxers include Humphrey Bogart, Billie Holiday, Nat King Cole, Charlton Heston, and Robin Williams.

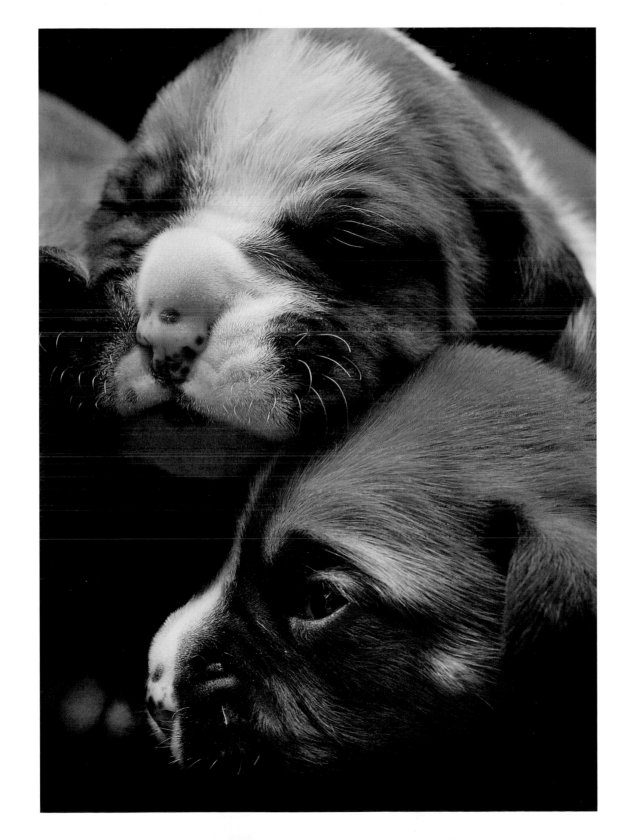

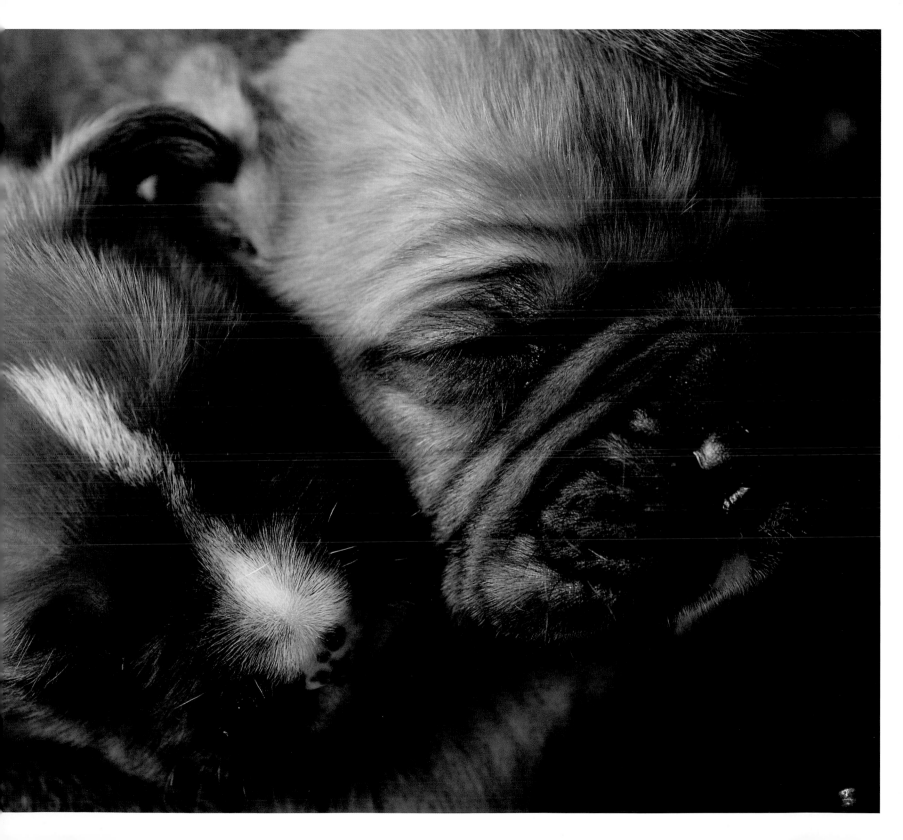

Dalmatians

15 days old

Dalmatian puppies are born with pure white fur. It isn't until they are about ten to fourteen days old that their iconic black spots begin to appear. This is also when the pigment in the puppies' noses begins to shift from pink to black. Dalmatians also have a genetic predisposition for deafness and it is estimated that up to 12 percent of Dalmatian puppies are born permanently deaf.

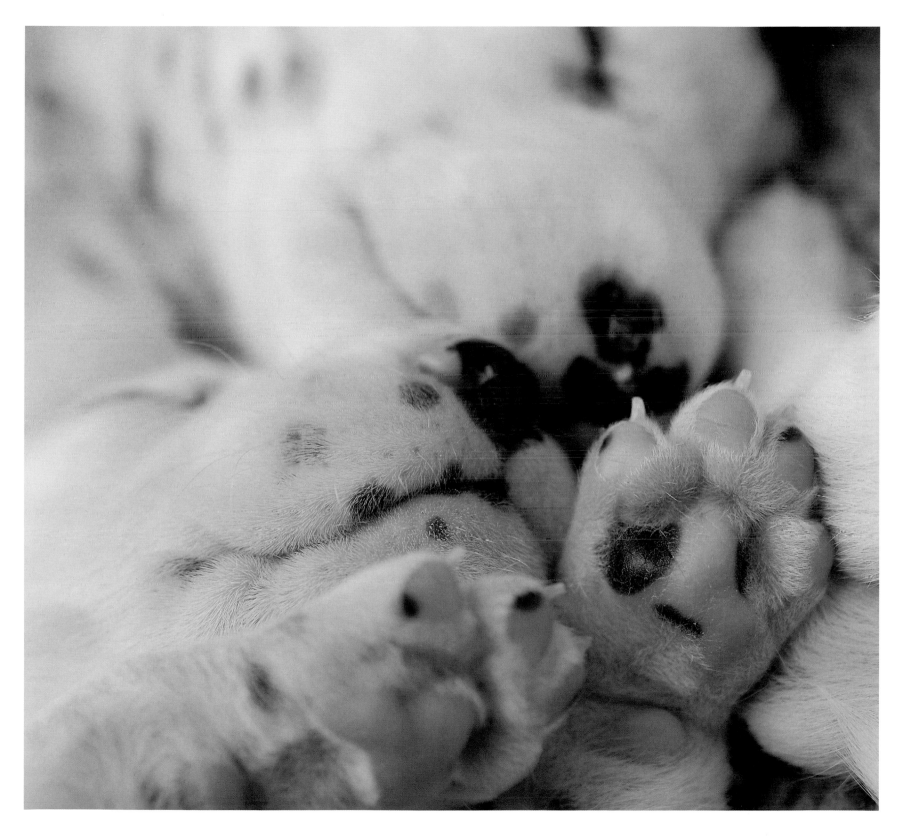

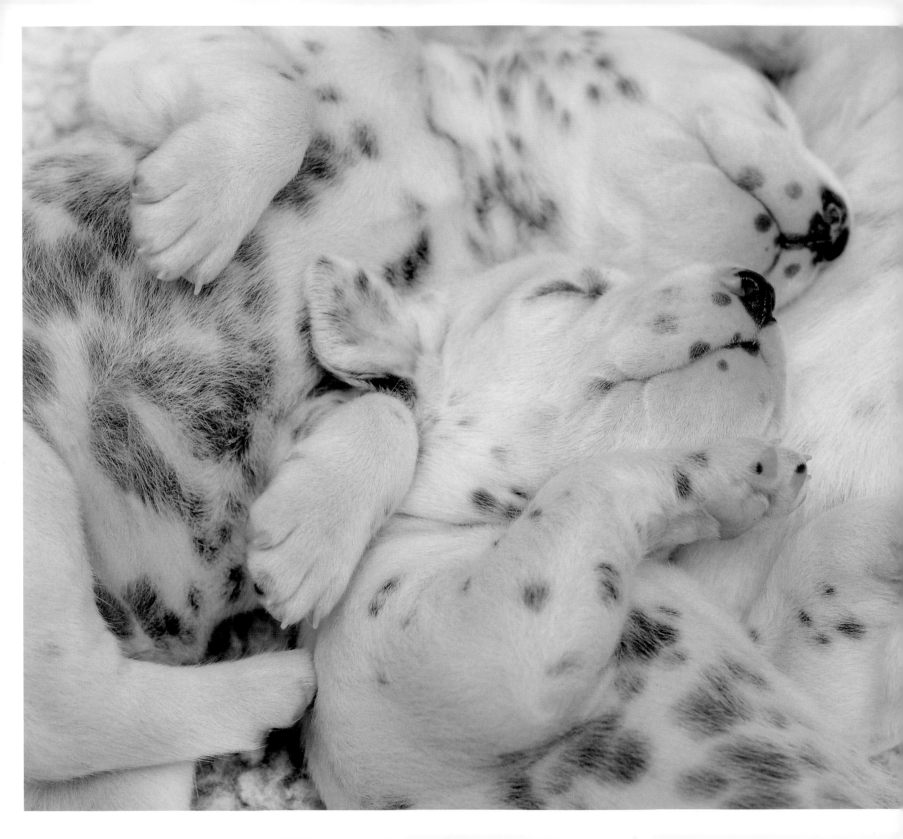

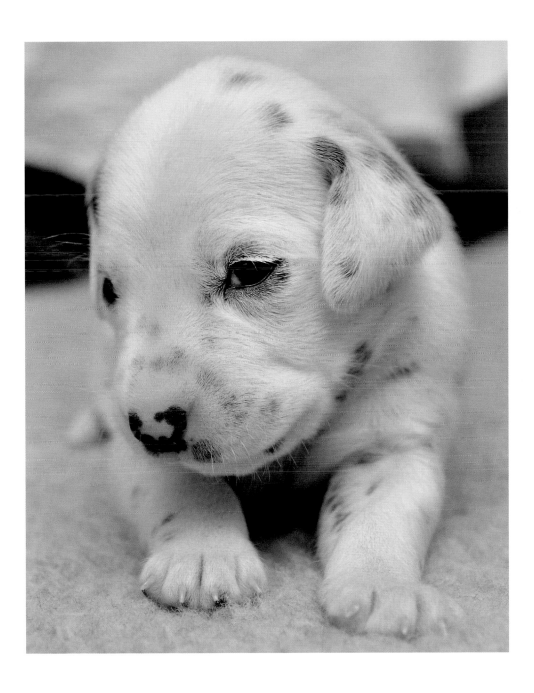

**German
Shorthaired
Pointers**

15 days old

The pointer designation is given to
several dozen breeds of dogs that
traditionally use their body language
in order to help hunters find game.
Upon spotting quarry, a pointing
breed will stop, raise one front leg
off the ground, lean forward, lower
its head and aim its muzzle towards
the game, showing the hunter where
to aim. This instinct is often devel-
oped in dogs at as young as two
months of age.

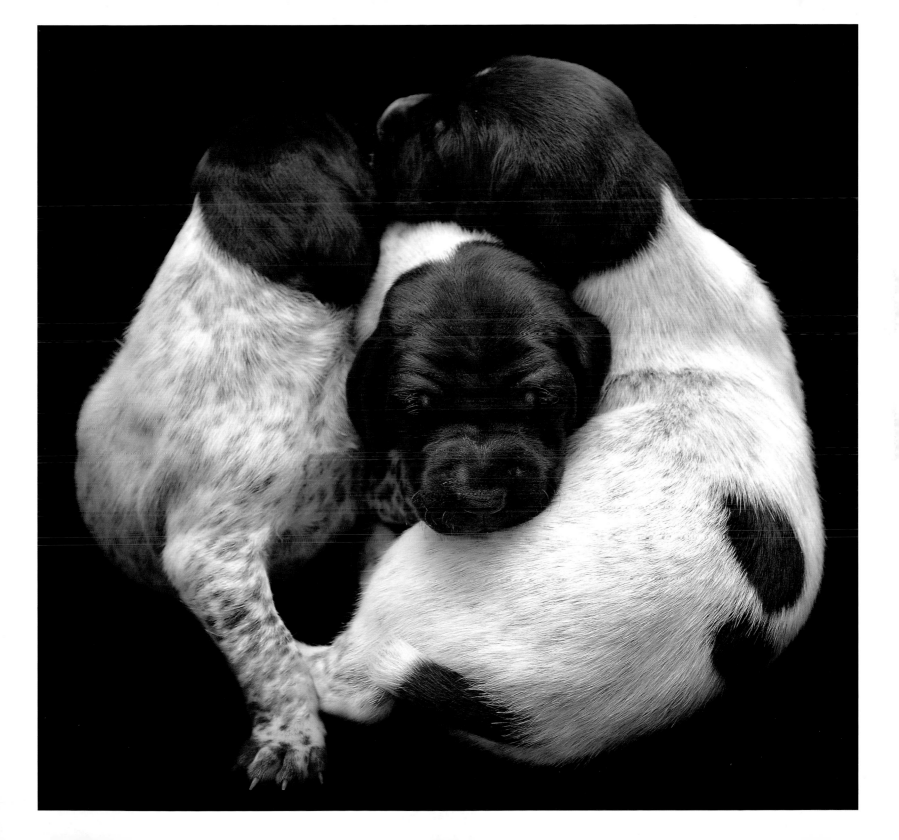

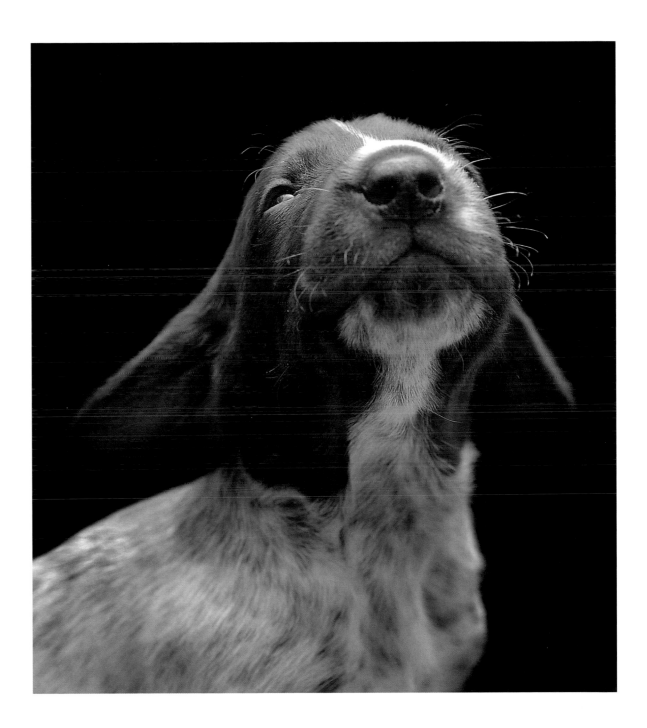

American Staffordshire Terriers

17
days old

Famed American Staffordshire Terriers include iconic dog pal Petey from the *Little Rascals* comedies, as well as decorated World War I hero Sergeant Stubby who is credited for saving countless soldiers' lives by warning them of imminent chemical attacks. For decades following World War I, the American Staffordshire Terrier was an extremely popular family pet in the United States. The breed's reputation for loyalty and tolerance for children was so noted that it even earned them the nickname Nanny Dog.

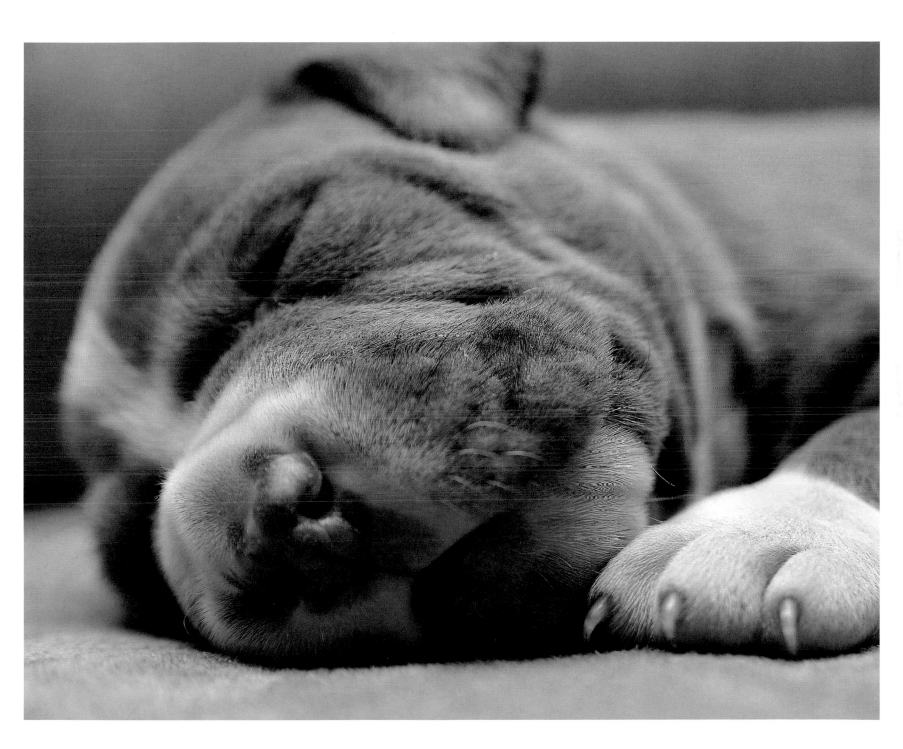

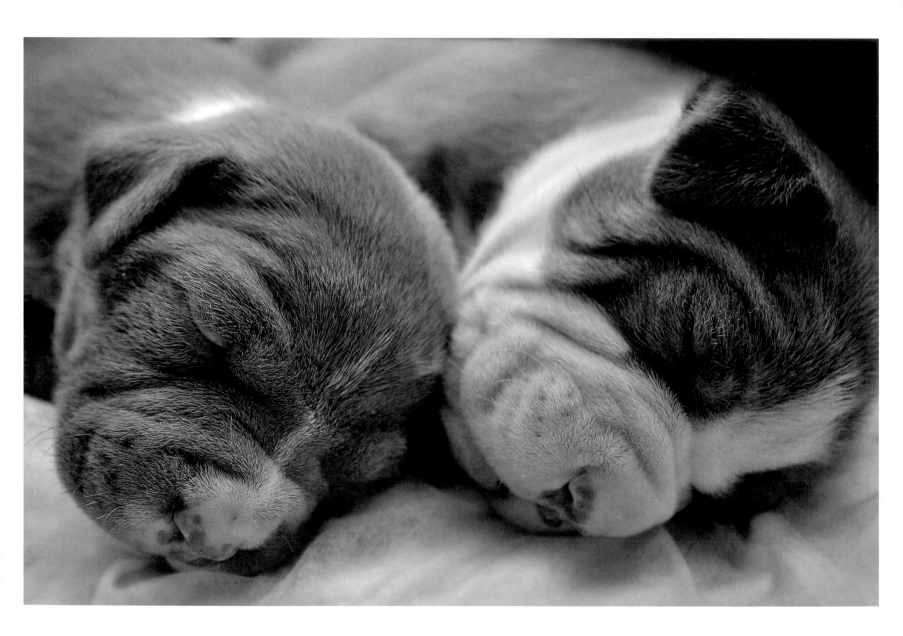

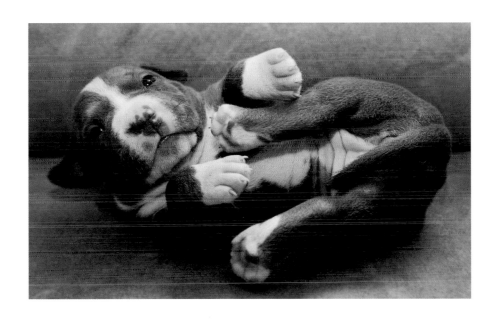

**Golden Retriever/Chocolate
Labrador Retriever Mix**

17 days old

Although this litter was the product
of a Golden Retriever father and
Chocolate Lab mother, no Choco-
late puppies were produced — all
of the offspring had either Golden
or Black coats. In Labradors, the
Chocolate coloration is carried by
a recessive gene which accounts
for why Black Labs are so much
more common than Chocolate or
Yellow Labs.

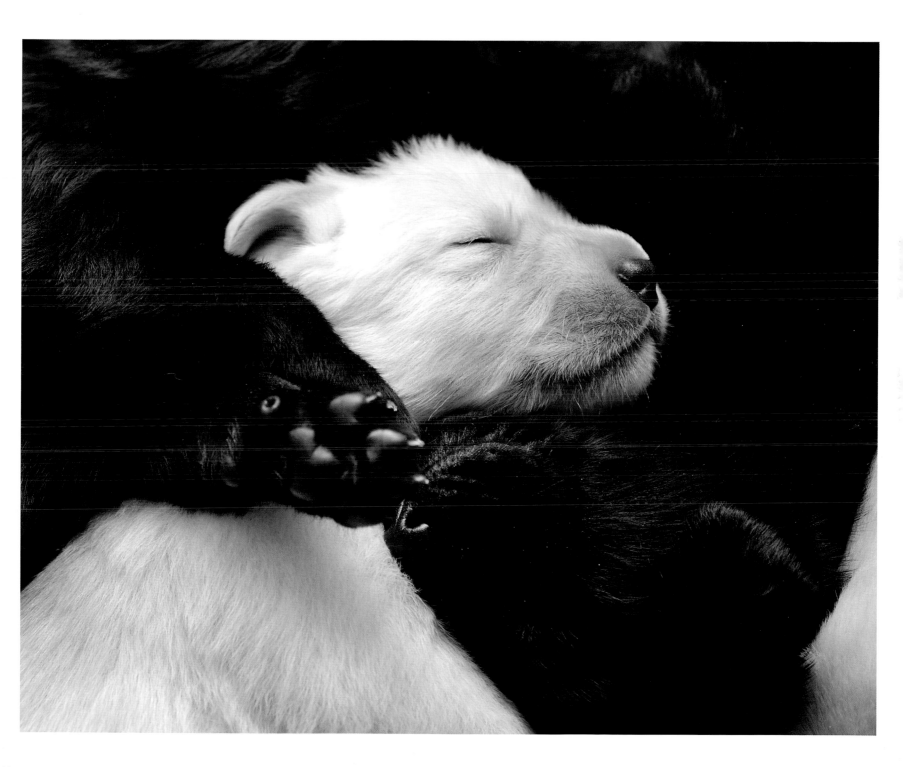

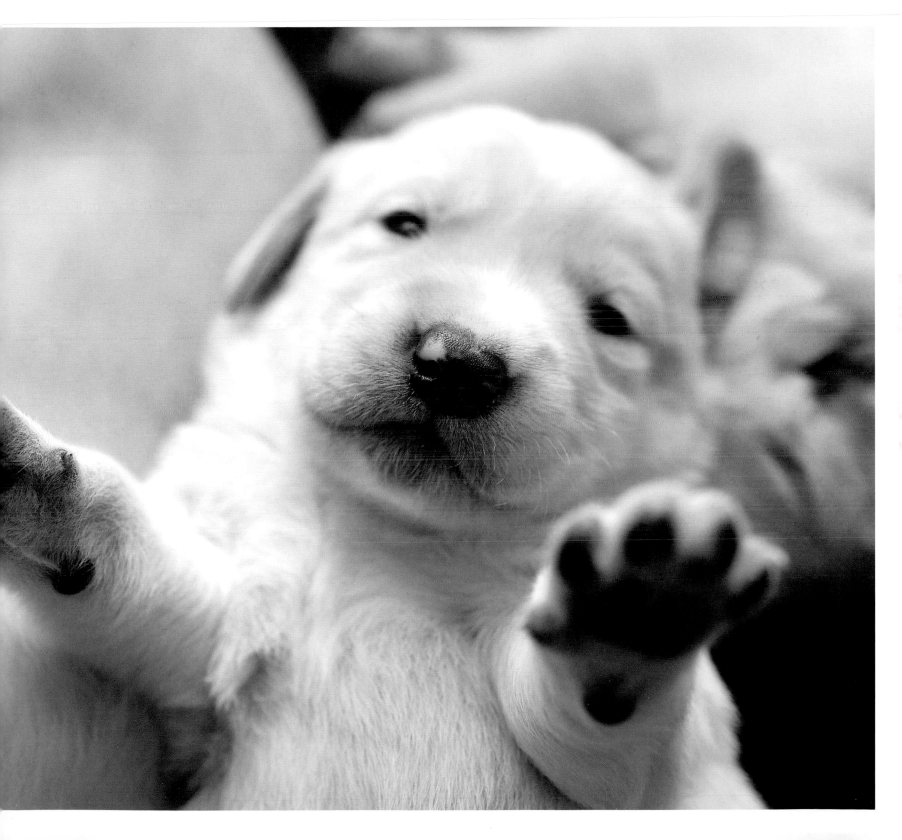

Boston Terrier/American Staffordshire Terrier/ Brittany Spaniel Mix

18 days old

The mother of this litter was dropped off at a shelter in Massachusetts just days before giving birth. The owner claimed that he had only realized the day before that the dog was in fact pregnant. Until arriving at the shelter, where she was given her own room and bedding, the two-year-old female had lived her entire life tied up outside in a yard. A DNA test ordered by the shelter returned some surprising results. Although the puppies were 25 percent Boston Terrier, American Staffordshire and Brittany Spaniel, the remaining 25 percent was comprised of some very uncommon breeds including Boykin Spaniel and Belgian Tervuren.

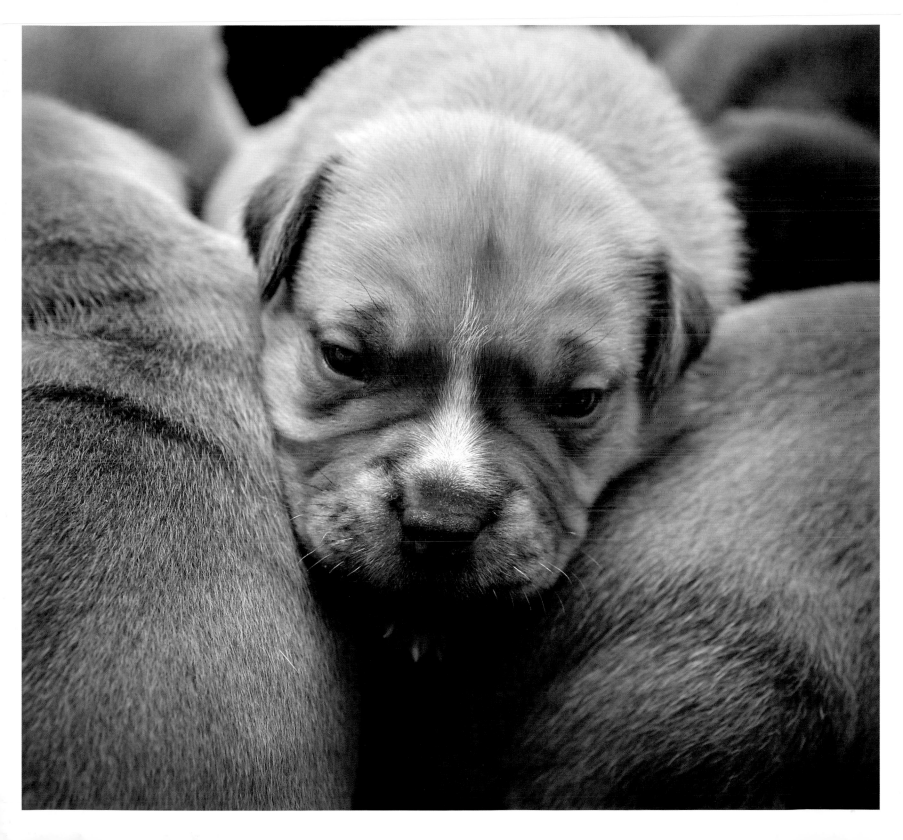

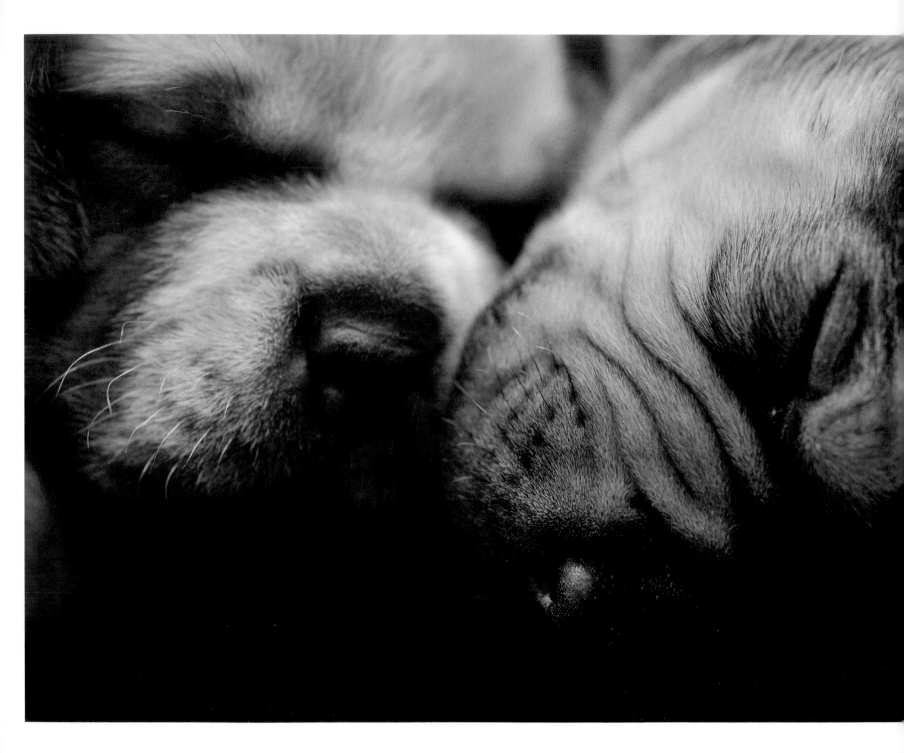

Pembroke
Welsh Corgis

18
days old

This litter of Pembroke Welsh Corgis shares their birthday with Wolfgang Amadeus Mozart, which prompted the breeder to choose musical names for each puppy. Siblings Aria, Allegro, Serenade, Tempo, Capriccio, Moonlight Sonata and future show dog candidate Go for Baroque, affectionately known as Barry, all began life on a good note.

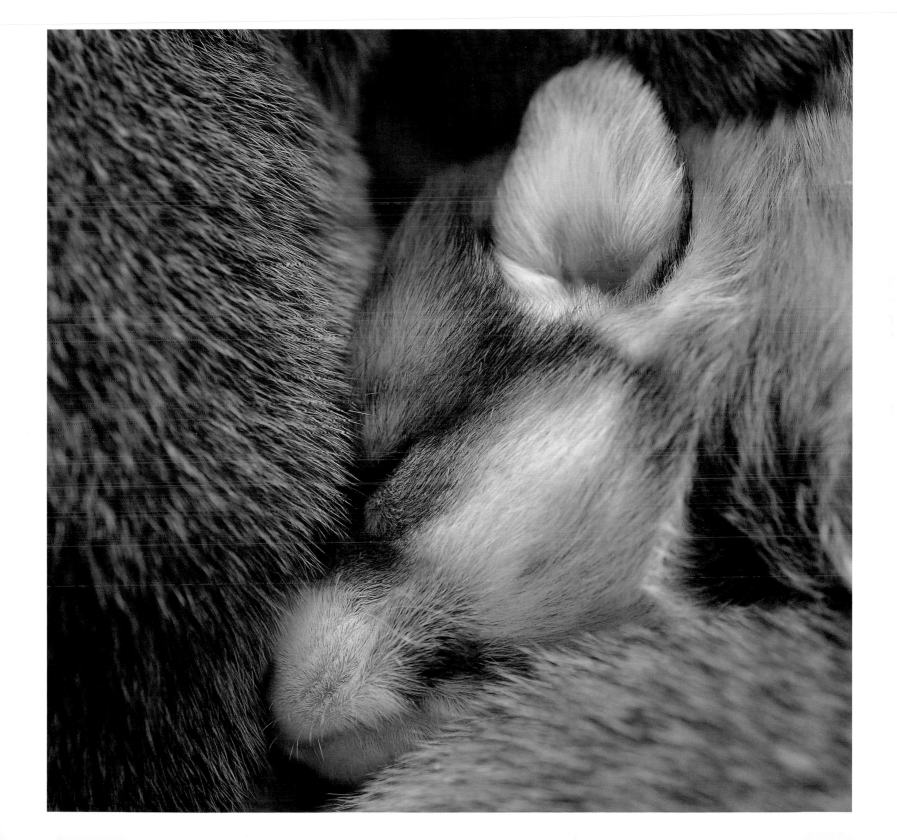

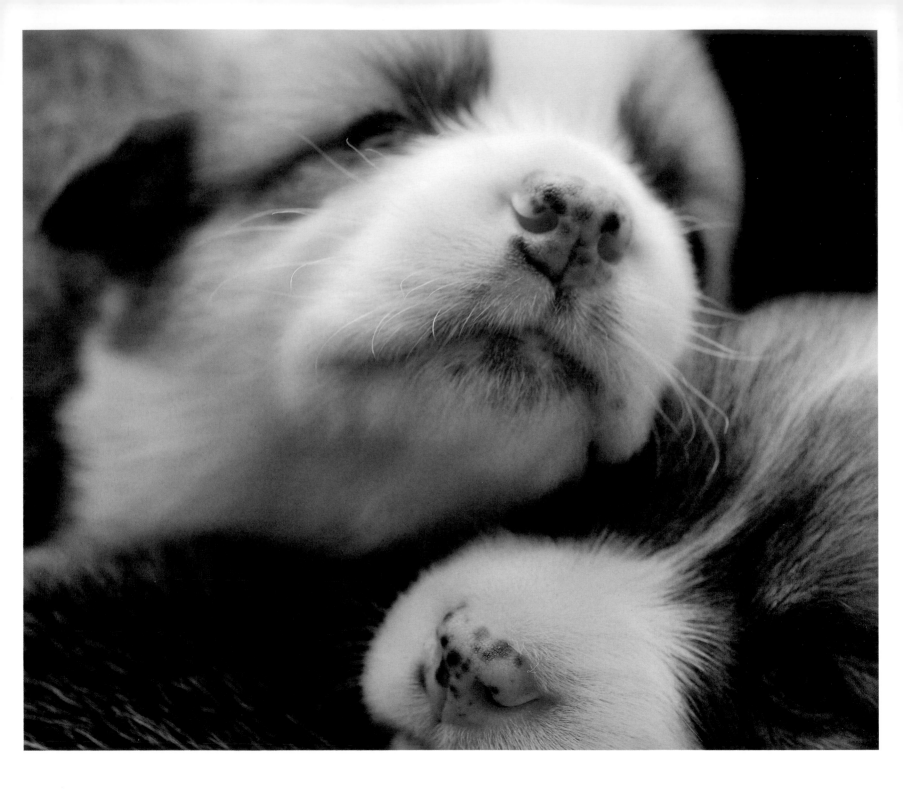

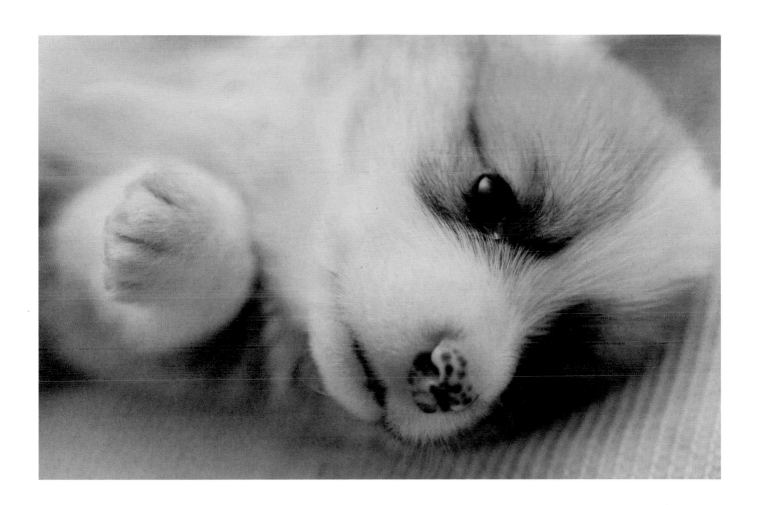

Mudis

19
days old

Mudis are a rare herding breed
that emerged in Hungary in the
nineteenth century. A born athlete,
the small, spry Mudi tends to excel
at agility, fly ball and other canine
sports. It is estimated that there
are only a few thousand Mudis in
existence worldwide with the largest
concentration still being in Hungary.

———————————————

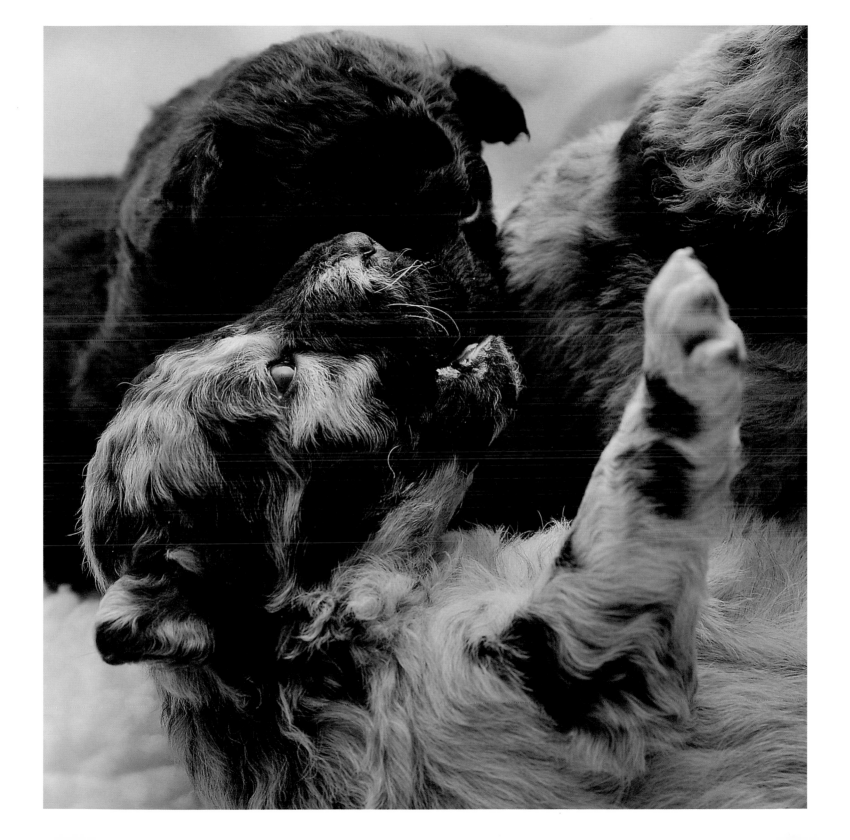

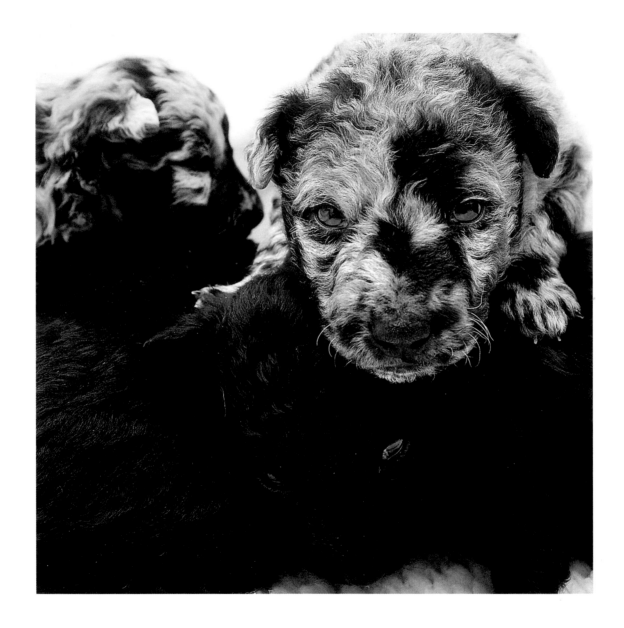

**Beagle/
Pointer Mix**

20
days old

This litter of puppies was being
raised in foster care in New Eng-
land. The pregnant mother was
originally found in a North Caro-
lina shelter, but was brought up to
Massachusetts by a rescue group
before giving birth. Gun Dogs like
Pointers, Spaniels, Setters, and
Labradors are much more com-
mon in animal shelters in southern
states than in other parts of the
country, and therefore are often
transported by various rescues
to the northeast and other parts
of the country where far fewer are
available for adoption.

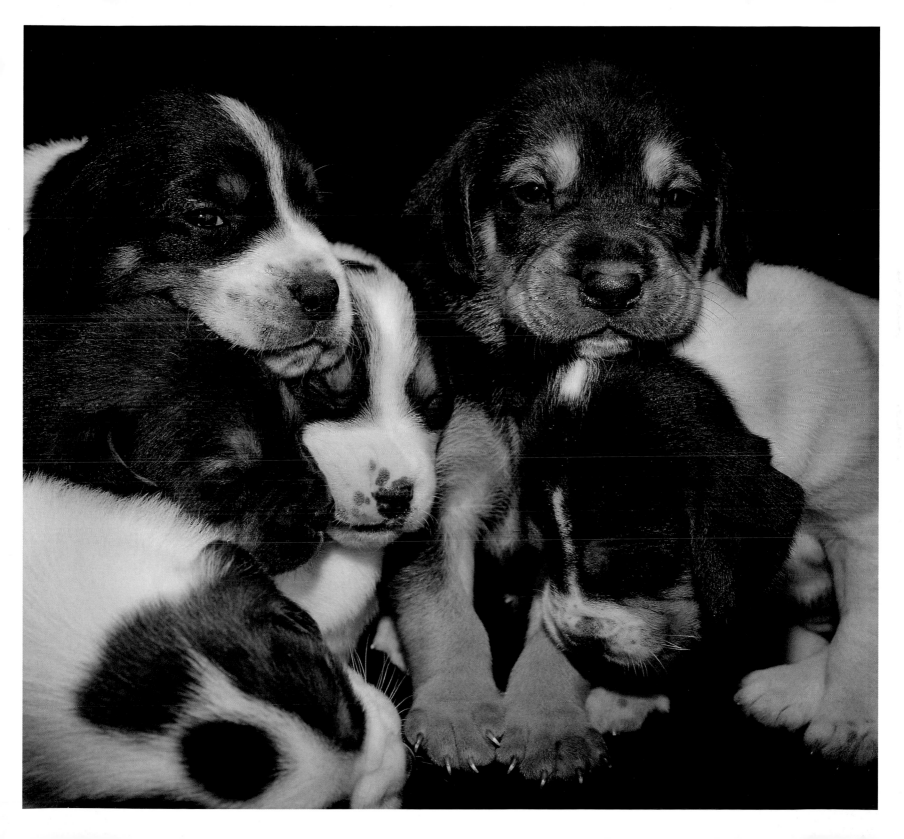

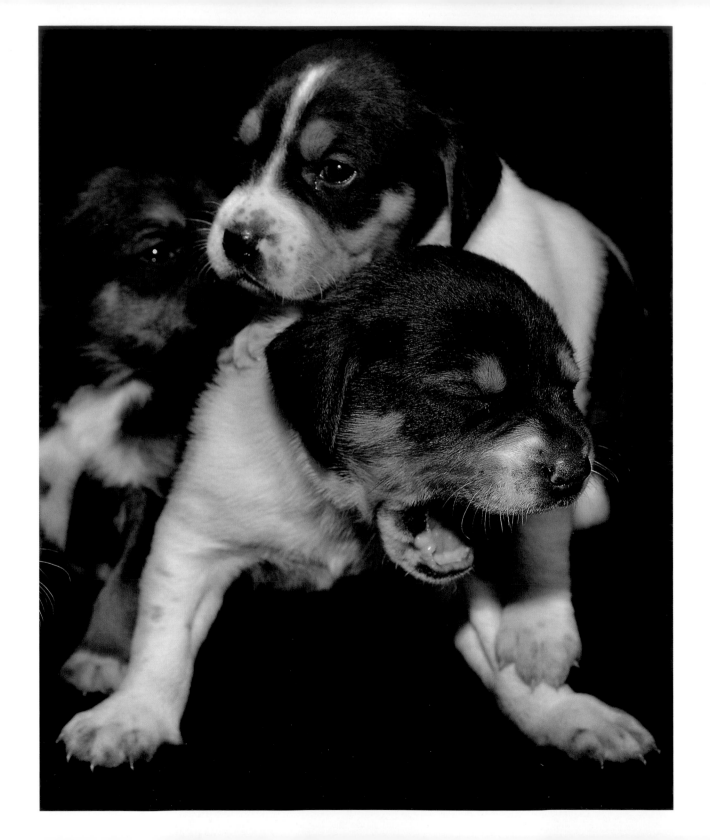

German
Shepherds

20
days old

The German Shepherd consistently ranks at the top of the AKC's registry of most popular breeds. Because of their intelligence, strength, keen sense of smell, and focus, German Shepherds are also the world's most prevalent military and police working dogs and have even been trained to parachute out of airplanes. Rin Tin Tin, an iconic symbol of canine nobility, is thought to be the most famed German Shepherd in American popular culture. Found on a World War I battlefield and adopted by an American soldier, Rin Tin Tin went on to star in twenty-three films and has his own star on the Hollywood Walk of Fame.

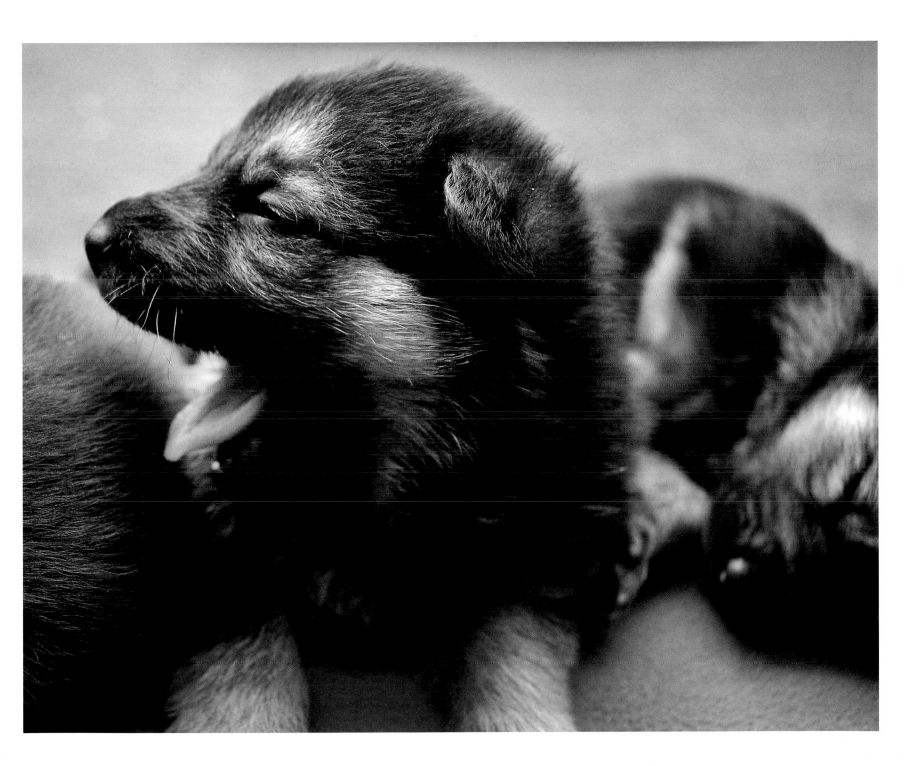

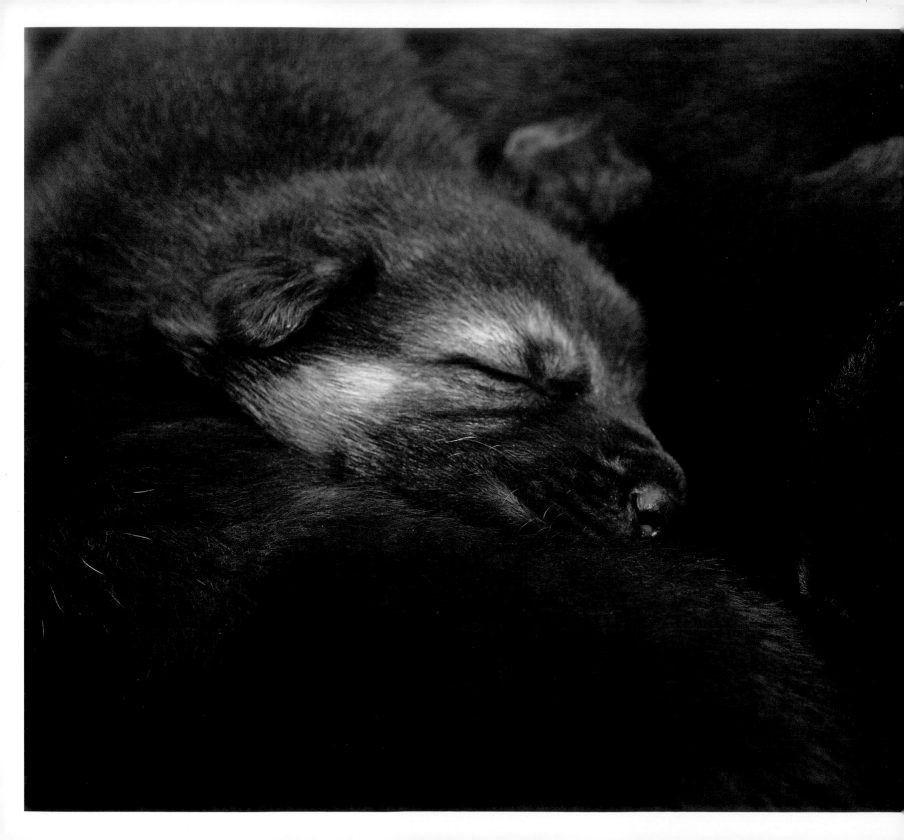

**Springer
Spaniels**

20
days old

Springer Spaniels are sporting dogs
traditionally used for flushing or
retrieving game. Working Springer
Spaniels are taught to have "soft
mouths," meaning that they learn
to retrieve and deliver quarry intact
to the hunter, without puncturing or
damaging the body of the animal.
Although this behavioral instinct is
present and revered in "gun dogs,"
it is by no means desirable for all
breeds. Terriers, for example, were
often bred to violently shake their
prey (often rats or other vermin) in
order to kill them quickly.

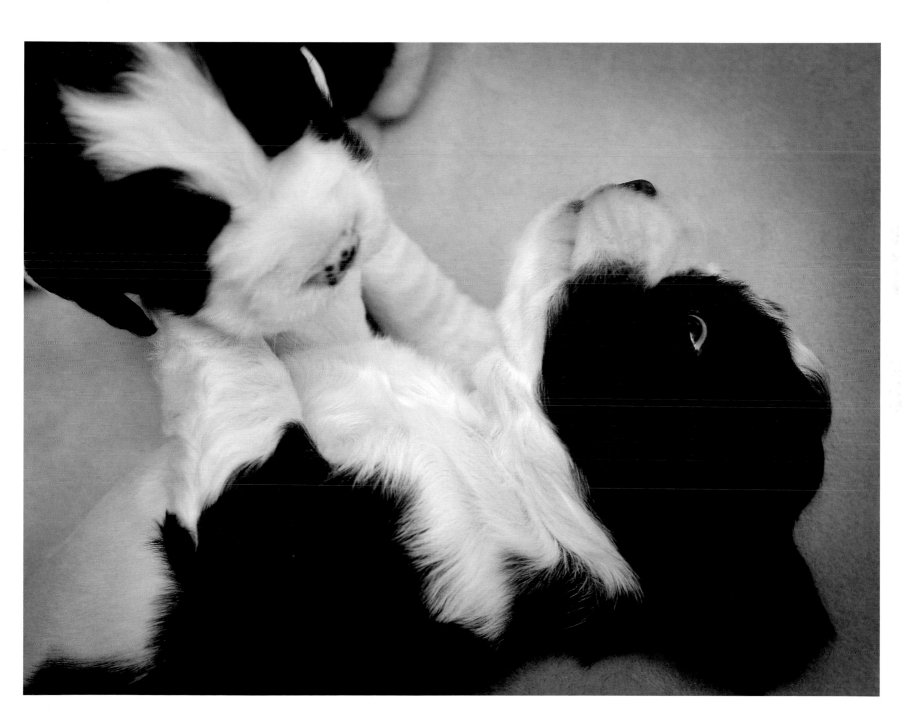

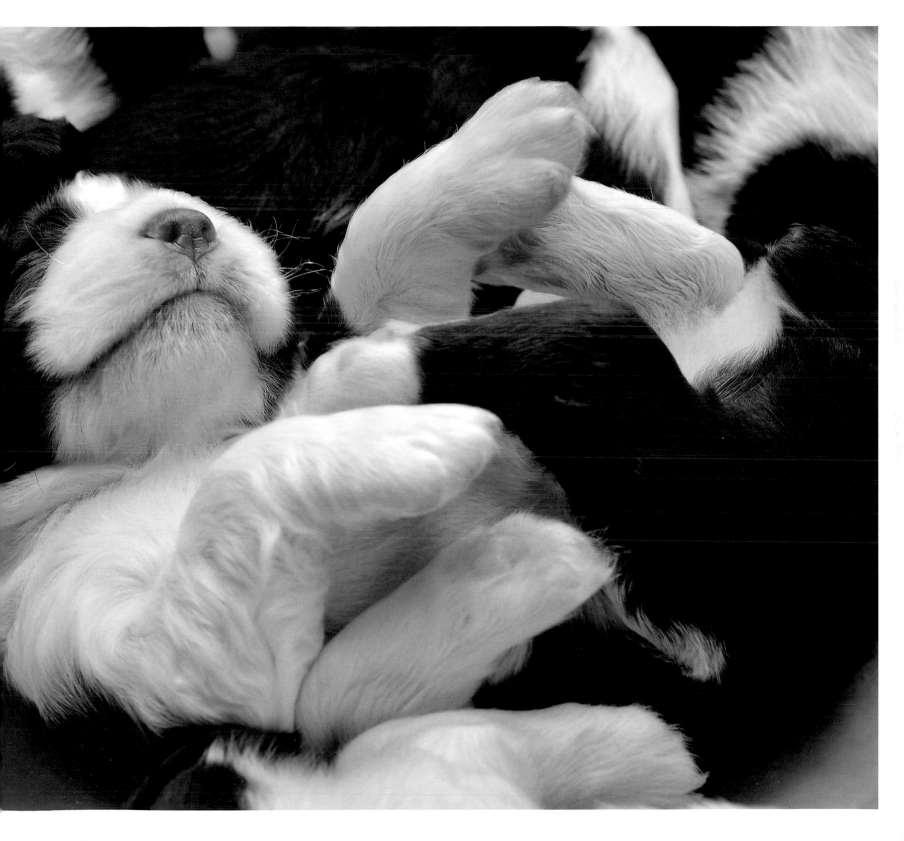

Golden Retriever/ Standard Poodles (Goldendoodles)

21 days old

A Goldendoodle is the result of pairing a Golden Retriever with a Standard Poodle. The mix has become very popular in recent years, particularly with families seeking a larger, low- or no-shedding dog. As with all hybrid breeds, however, Goldendoodle puppies may favor either parent, so the shedding tendencies will vary from dog to dog.

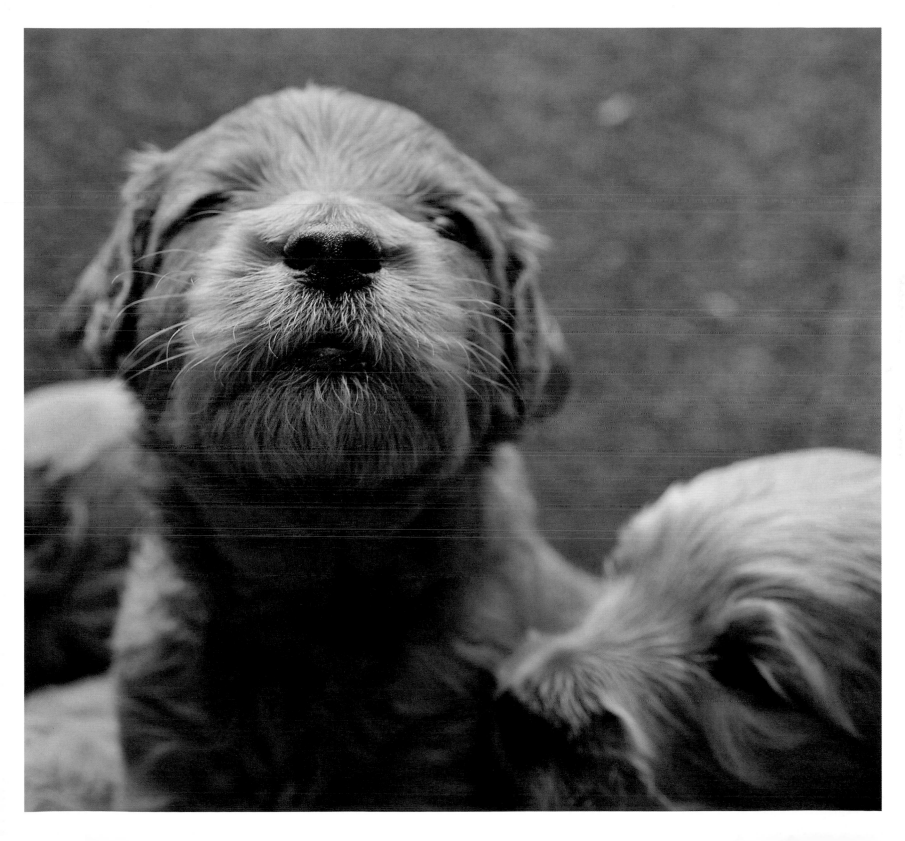

Bloodhounds

21 days old

Possessing the keenest sense of smell of any dog breed in existence, the Bloodhound is a born sleuth. Bloodhounds have been bred for over one thousand years specifically for the purpose of tracking human beings and are used all over the world for finding criminals, missing people, and lost children. Researchers have estimated that a Bloodhound's nose consists of 4 billion olfactory cells, or "scent receptors" making their sense of smell approximately one thousand times better than the average human. The Bloodhound is the only animal whose evidence is admissible in a U.S. court.

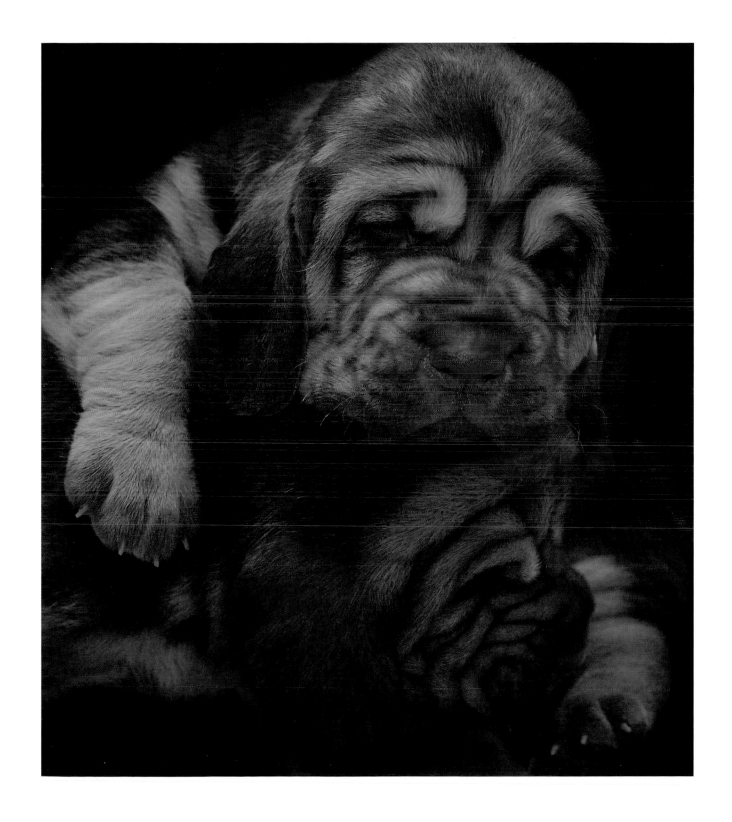

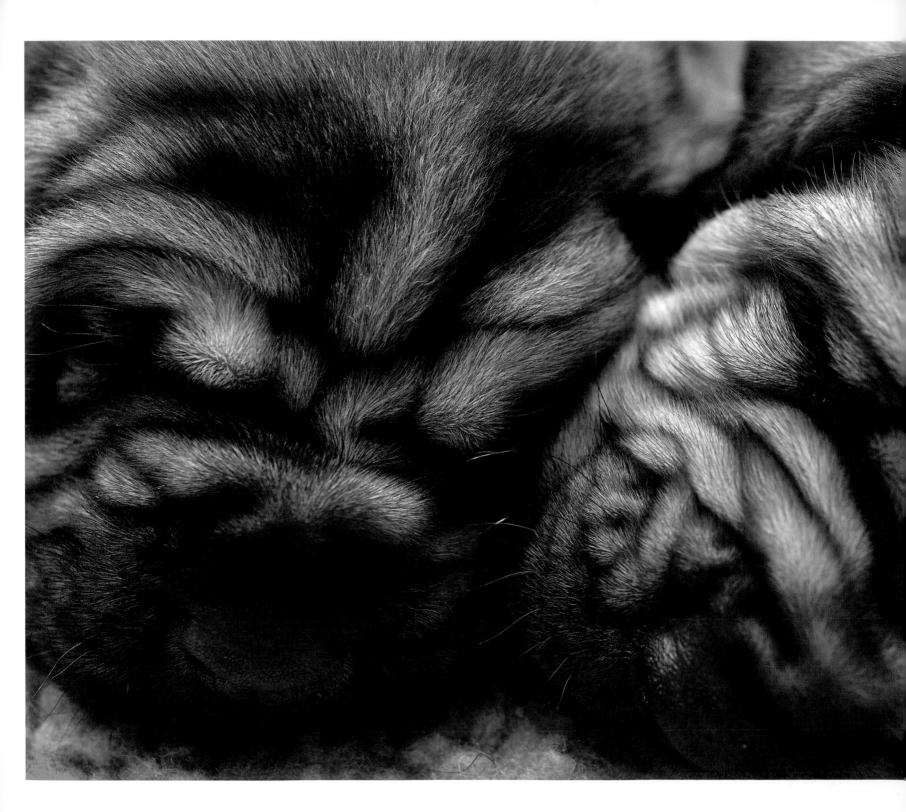

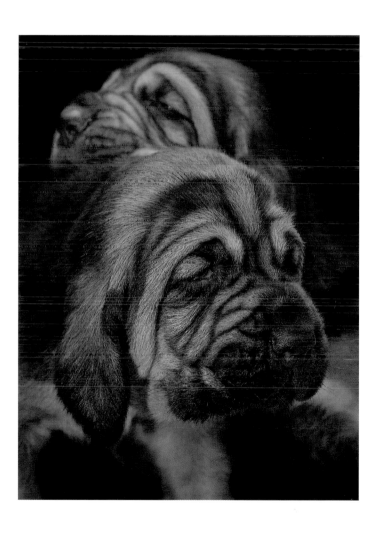

Italian
Spinones

21 days old

After a long and difficult delivery,
this Italian Spinone delivered
her ninth and final puppy, which
appeared to be stillborn. Seeing
that the puppy was not moving
or breathing, the breeder quickly
removed the placenta and began
rubbing the little body. Next, she
removed phlegm from the throat by
swinging the puppy in a centrifugal
motion and then blew air into its
tiny mouth. Seconds later, the tiny
dog sprung to life, legs pumping
in the air, and took its first breaths.
The pup, a female, continued to
thrive and weighed in at 20 pounds
at eight weeks of age!

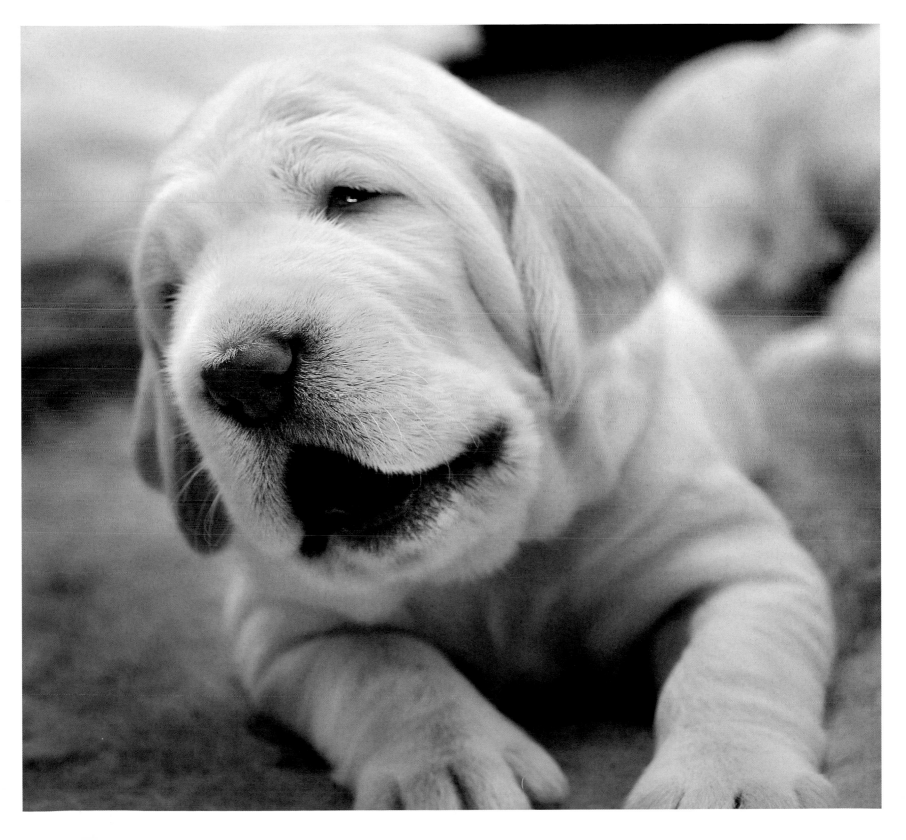

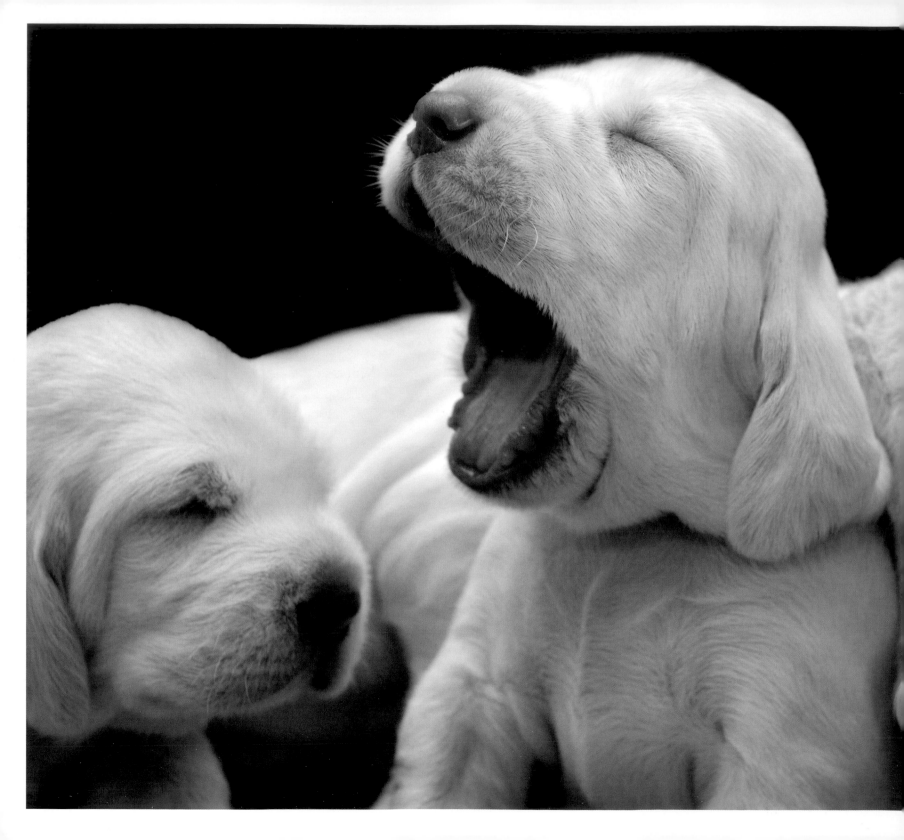

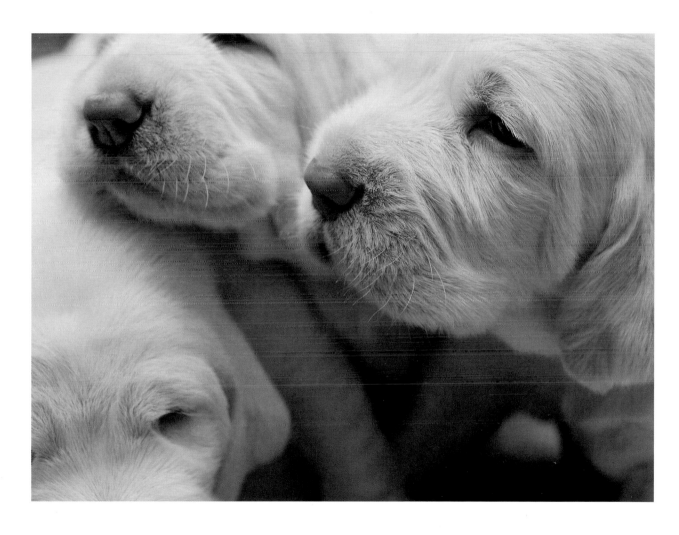

Golden Retrievers

21 days old

Several generations of Golden Retrievers live together in this hobby breeder's home, and two of the females share much more than just the couch. The grandmother of these pups actually developed sympathy lactation and shared in the nursing duty with the litter's mother.

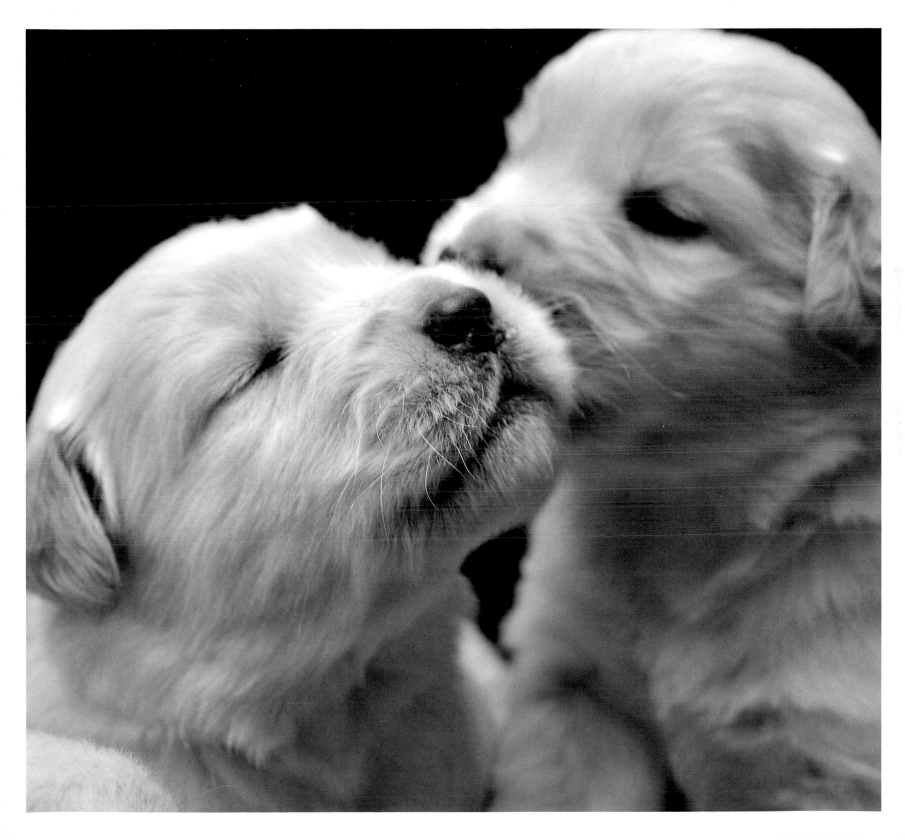

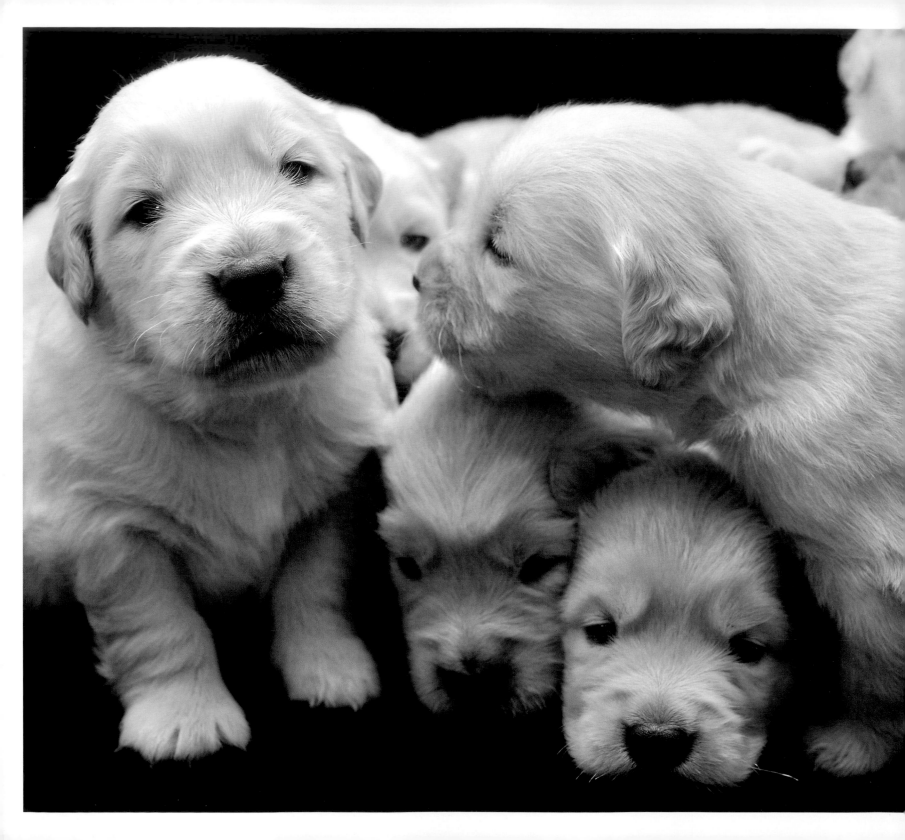

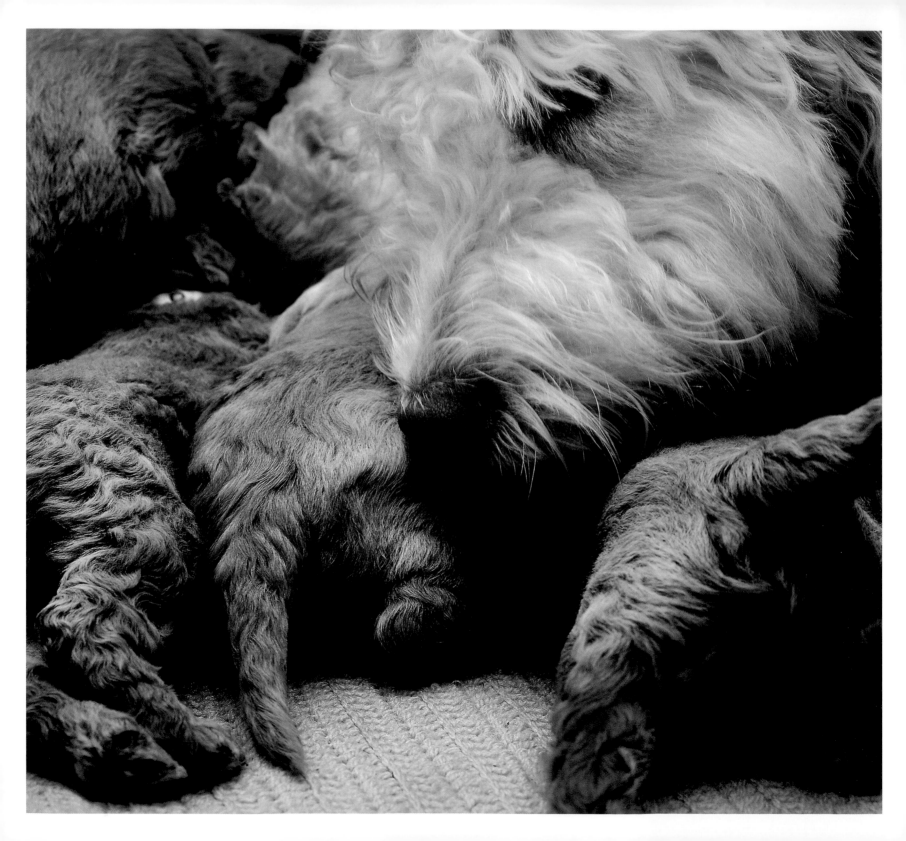

Puppy Mills:
Questions & Answers

What is a puppy mill?

A puppy mill is a large-scale commercial dog breeding operation where profit is given priority over the well-being of dogs. Puppy mills are generally characterized by their overcrowded, inhumane conditions and the production of unhealthy puppies that are sold to animal brokers, laboratories, and to pet stores.

What are the conditions like in puppy mills?

Puppy mills house dogs in extremely crowded, unsanitary "warehouse" conditions. Often, dogs live in small wire cages stacked on top of each other to maximize space and minimize cleanup. Puppy mill mothers can live their entire lives in these fetid crates without ever being allowed sunlight, fresh air, exercise, or toys. These dogs have little to no veterinary care and are forced to have litter after litter until they can no longer reproduce, at which time they are disposed of. Puppies produced in Puppy Mills are taken from their mothers at a very young age and shipped to brokers and pet stores around the country. Puppy mill puppies are notoriously unhealthy, and often suffer from heart and kidney disease, deafness, respiratory disorders, and a host of other ailments stemming from neglectful conditions and irresponsible over-breeding.

Where are puppy mills?

Puppy mills are everywhere. However, the states with the highest concentration are the agricultural states, such as Arkansas, Iowa, Kansas, Missouri, Nebraska, Oklahoma, South Dakota, and Lancaster County, Pennsylvania.

The ASPCA estimates that there could be as many as ten-thousand puppy mills in the United States.

How do I know if my local pet store sells puppy mill dogs?

Virtually ALL of the puppies sold in ALL pet stores come from puppy mills.

What's the difference between a reputable breeder and a puppy mill?

Reputable breeders are devoted to their dogs and are driven by a love for the breed rather than profit. Their aim is to produce healthy, happy, well-socialized puppies, and to place them in loving, lifelong homes. They do not sell their puppies to pet stores or to animal brokers.

While puppy mills always offer many different breeds of purebred puppies, reputable breeders are almost always dedicated to one breed.

Reputable breeders raise their puppies inside their homes, by hand.

A reputable breeder will invite you to visit their homes or kennels and to meet the parents of the puppy. They will also "guarantee" their dogs. A good breeder will always take one of their dogs back in case of poor health or the need to re-home them.

How can I avoid buying a puppy mill dog?

✖ Don't buy a puppy in a pet store.

✖ Don't buy a puppy online.

✖ Adopt.

✖ If you have your heart set on a purebred, try breed rescues first. If buying from a breeder, choose a responsible local breeder. Meet them in person, meet their dogs, and tour their facilities before buying a puppy.

Where can I find a purebred rescue?

The American Kennel Club website is a good place to start: www.akc.org/breeds/rescue.cfm

How can I find out more about puppy mills?

There is a wealth of information online. These organizations' websites offer a lot of valuable facts and ways you can help: www.aspca.org/PUPPYMILLS; www.humanesociety.org/issues/puppy_mills/; www.prisonersofgreed.org

Are there puppy mills in the UK?

Yes, they are called "puppy farms" or "battery farms," but are otherwise exactly the same as U.S. puppy mills. They are just as inhumane, and like their U.S. counterparts, also sell the overwhelming bulk of their puppies to pet stores, often through brokers or dealers.

A few organizations at the forefront of U.K. anti-puppy farm advocacy are:

✖ **The Kennel Club**
www.thekennelclub.org.uk/item/208

✖ **Dog's Trust**
www.dogstrust.org.uk

✖ **Puppy Love Campaigns**
www.dogs-r-us.org/

Acknowledgments

I want to extend my deepest gratitude to the dozens of families, breeders, and shelters who welcomed me into their homes and trusted me to photograph their tiny charges. This book is only possible because of you. From stewards of champion bloodlines, to foster families, to animal control shelters, you represent a vast variety of niches within the dog world, but perhaps not so surprisingly, I found that you have a lot in common. Each and every one of you shares a profound love of dogs and a commendable sense of obligation to current and future generations of them. You are an inspiration.

A special thank you to my agent and friend, Joan Brookbank, and my husband, Jesse, for always keeping the faith.

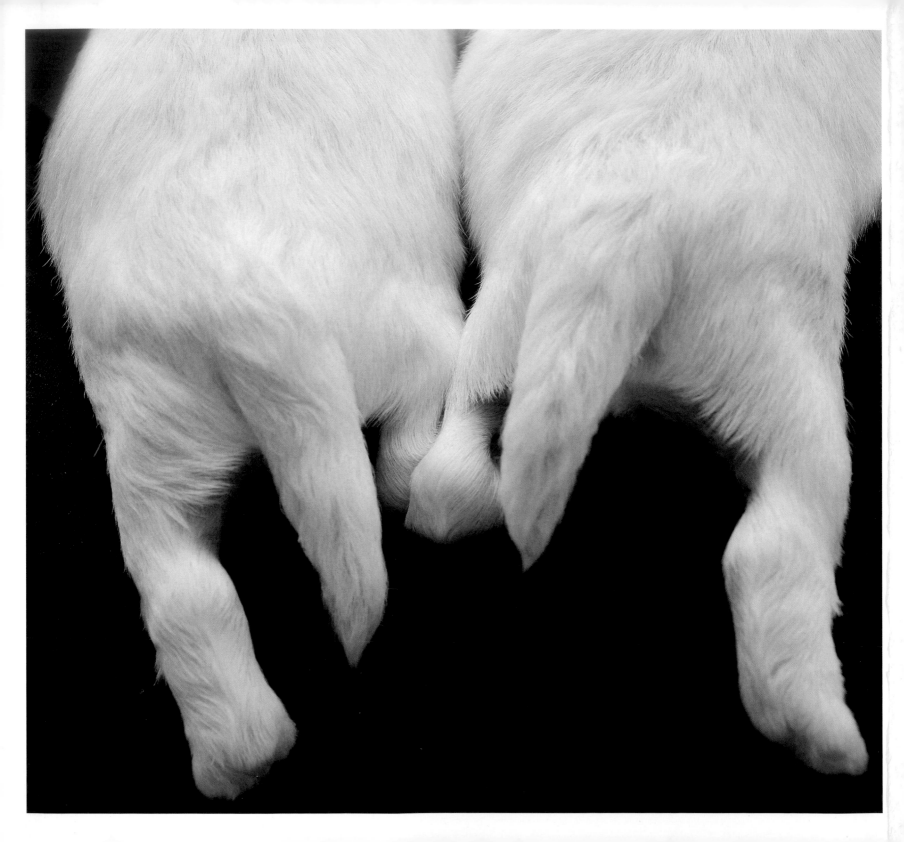